GUIDE TO
creative
Handlettering

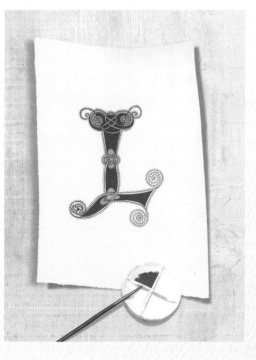

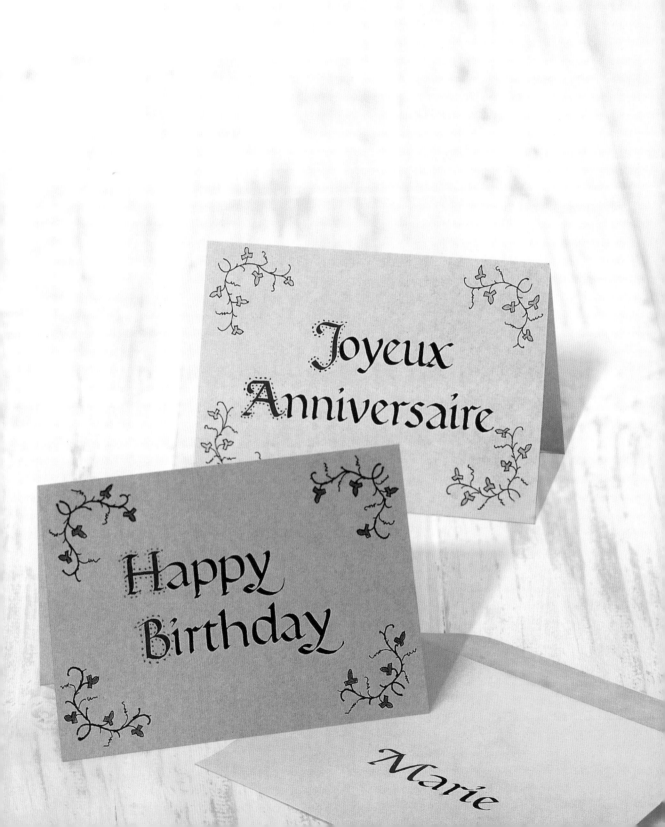

GUIDE TO

creative

Handlettering

over 20 step-by-step projects & creative techniques

FIONA GRAHAM-FLYNN

CICO BOOKS
LONDON NEW YORK

Published in 2019 by CICO Books
An imprint of Ryland Peters & Small Ltd

20–21 Jockey's Fields 341 E 116th St
London WC1R 4BW New York, NY 10029

www.rylandpeters.com

10 9 8 7 6 5 4 3 2 1

First published in 2006 by CICO Books as part of
The Complete Guide to Calligraphy

ISBN: 978-1-78249-599-4

Printed in China

Author: Fiona Graham-Flynn
General editor: Professor Ralph Cleminson
Project editor: Robin Gurdon
Editor: Richard Emerson
Designer: Eliana Holder
Photographer: Geoff Dann
Stylist: Sammie Bell

CONTENTS

INTRODUCTION: THE HISTORY OF SCRIPTS, LETTERING, AND WRITING

Throughout history, cultures have looked for ways to record their words for others to appreciate, using materials as diverse as stone, reeds, skins, and clay. But for these ancient scribes, communication of ideas alone was not enough—they also sought to make their work pleasing to the eye. And so was born the calligrapher's art.

It is not known when human beings first began to write. The earliest examples are of developed writing systems that must already have had a considerable history behind them. It appears that writing arose independently in different places—in China, in the Indus Valley, in the Eastern Mediterranean, in Central America, and quite possibly elsewhere—and spread over the ancient world, with different peoples either adopting existing scripts or devising their own in imitation of them.

Above: This image depicts a form of pictographic text, dating from c. 4000 B.C.E., that was a forerunner of modern Chinese.

It is most likely that the origin of writing lies in an attempt to draw a likeness of the objects and actions they were intended to portray. Think of the beautiful depictions of animals painted on cave walls by our Stone Age ancestors hundreds of thousands of years ago. Over the millennia there followed a gradual shift from an accurate representation of the object to a purely symbolic form. As a result, the sign became dissociated from the image it depicted and began to develop a meaning of its own.

This early form of visual communication has not died out entirely and can still be seen in use today, especially in public buildings, where people of diverse nationalities and languages gather together. For example, a simple image of a man placed on a bathroom door is not a picture of anyone in particular, but an indication that behind the door is a lavatory to be used by members of the male sex. Similarly, a knife-and-fork symbol has become an almost universal icon for an eating establishment, regardless of the type of food that might be offered (which may be eaten with a spoon, with chopsticks, or with the fingers!).

This is not writing as such, however, as it conveys meaning only if we see it in its correct location or context. For example, the "man" sign painted on a blank wall would be meaningless. The development of a true writing system requires a further shift: a system of signs arranged in such a way that their specific meaning may be gleaned from the signs alone, regardless of their location or context.

The earliest writing systems were pictographic. That is, the symbol marked down was a simplified version of the object it represented. This developed into a logographic system, where characters or graphs represent units of concept or meaning, as in early

Japanese and in Chinese writing today. The way a character is drawn has no connection with the way that the word it represents is pronounced. In Chinese, two words that happen to sound the same are likely to be represented by two completely different symbols.

However, in many cultures a further separation took place when signs ceased to have inherent meanings and came to represent sounds instead. The earliest examples of this were lists of characters representing syllables, known as "syllabaries," such as Linear B, an ancient form of writing used on the island of Crete in the Mediterranean, and on mainland Greece, and dating from c. 1400 to 1200 B.C.E. Syllabic scripts are the ancestors of the modern alphabet, in which each character represents an even smaller unit of sound.

The various writing systems have their own unique advantages. A logographic system is good for representing a language with invariant word forms, such as traditional Chinese, but insufficient for Japanese, which supplements its logographic symbols with a syllabary.

A syllabary is good for languages with open syllables, but less well-suited to those that have consonant clusters or final consonants; and it is often awkward to represent any language with an alphabet that was designed for another, or for an older form of the same language, as the often eccentric spelling found in English testifies.

Not all the writing systems of the past have descendants that are still in use today. Some, however, have been extraordinarily prolific, notably Chinese, which spread throughout East and Southeast Asia (although it is no longer used for Vietnamese). Phoenician, which was derived from Egyptian hieroglyphs, is the ancestor of the modern European and Middle Eastern alphabets, and can be linked, via various extinct Central Asian scripts, to a vast array of Asian forms of writing, ranging from Mongolian in the north to the various Indic scripts in the south, including ancient Sanskrit and the modern written languages of the Indian subcontinent.

The development of writing has also been heavily influenced by the development of the writing materials used to produce it. It is possible to write on any flat surface. Stone, wood, plaster, clay, metal, papyrus, parchment, paper, wax, bark, palm leaves, and

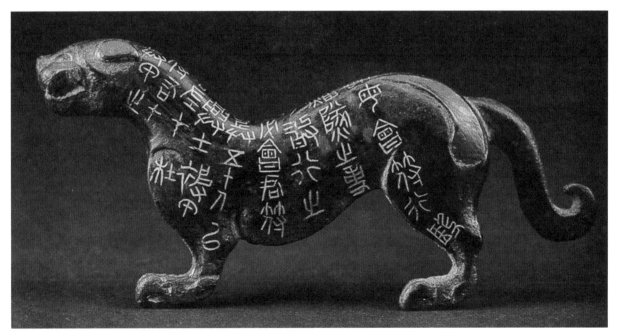

Above: This bronze tiger from China's Qin dynasty (221–206 B.C.E.) is inlaid with gold and covered in calligraphy. The work is in two pieces—one kept by the Emperor, and the other by his leading general. When the two pieces were fitted together it proved the authenticity of the Emperor's orders.

Above: The use of a brush in Japanese calligraphy creates a more flowing style of writing that allows subtle changes of thickness and direction.

pottery have all been inscribed or incised by different cultures at various times.

The media in which—and on which—writing was performed have played a large part in determining the form of the script that developed. The widespread use of the brush in China and Japan has done much to influence the bold, sweeping strokes of the characters that make up their writing systems.

Cuneiform is a script designed to be impressed on clay, just as Ogham and Runic are meant to be incised on stone or wood. Europeans often refer to the script of the Orkhon inscriptions or to the Hungarian *rovásírás* (literally "cut writing") as "runes" simply because of the similarity of their shapes, even though, historically speaking, they have nothing to do with the Runic alphabet that developed in Northern Europe from the third century C.E.

These various media not only greatly affect the form of the writing that they carry, they also play an important part in determining how workable, portable, and durable a particular piece of writing will be. Many examples of the most ancient forms of writing that have survived to modern times were inscribed on stone—perhaps the most durable writing material of all. But stone-engraved writing tends to be of a public nature. It was generally intended for a wide audience and had to convey information of sufficient importance to have been worth all the time, effort, and cost of having someone carve it.

So stone carvings can tell us a great deal about, for example, what ancient towns and cities were

called, their greatest generals, or their most influential statesmen—as well as the laws and proclamations they passed—but are less likely to contain more mundane information, such as business transactions, items of news, declarations of love, and similar personal correspondence of the time.

Other pieces of ancient writing that have lasted till the present day have frequently done so simply because of chance events, such as the huge fire that destroyed the palace at Knossos, the principal city of the Minoan people of Crete, which was occupied until c. 1200 B.C.E. This fire was so intense it acted as a kiln, hardening the unfired clay tablets marked with Linear B inscriptions that were stored there, and turning them into durable pottery, thereby preserving them for modern times.

The hot, desert climate of Egypt also preserved much early writing of the Egyptians, not only the hieroglyphs painted on the walls of the pharaohs' tombs, but also vast quantities of papyrus, including much that is of critical importance for the textual history of the New Testament. Where a cheap and portable surface for writing is readily available, the opportunities for writing are much greater, as it can be used for many more purposes. Just as the Egyptians and their Mediterranean neighbors used papyrus, for the Chinese, the most important writing material was paper.

The visual impact of writing can vary considerably, with much greater care being given to text that

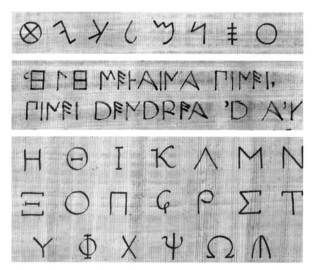

Above: Over many hundreds of years, the Phoenician script (top) gradually changed to a form of Greek that would be recognizable today (bottom). (Script recreated by author.)

was intended to be long-lasting, public, and of high status, than that which was ephemeral, personal, and purely practical in purpose. Indeed, the Egyptians categorized scripts in one of three ways: hieroglyphic, hieratic, or demotic, the first being used for the most solemn and ceremonial purposes and the last for the most pragmatic. However, the strong pictorial element in these hieroglyphs means that they are still as much drawing as calligraphy.

The alphabetic scripts of the ancient world also reveal a clear distinction between writing whose form is intended to impress, and writing that is used to convey a simple meaning. For example, in the ancient Roman world, there was a clear difference between scripts used for inscriptions carved on ancient monuments, and the graffiti scrawled on walls, such as those of Pompeii, which were rediscovered when the city was excavated in 1748. Until that time, Pompeii had lain buried and forgotten under volcanic dust, following the eruption of Mount Vesuvius in 79 C.E. that killed many of its citizens. The Roman poet Ovid (43 B.C.E. −17 C.E.), in the preface to his collection of poems *Tristia*, describes the luxury books of his day—contrasting them with the sort of book in which he expects his own work to circulate.

The emergence of calligraphy, with its emphasis on the decorative aspects of writing as much as communication, led to the development of writing

Above: Celtic scribes decorated their manuscripts with comic or fantastic animal designs that often had symbolic meaning.

as an art form. This is particularly true of China and Japan, where the form and variety of the characters provide particular scope for decorative impact, and where considerable importance has long been attached to standards of calligraphy.

Arabic script has considerable decorative potential as well. This was encouraged by the fact that in certain Middle Eastern cultures depicting the natural world in a realistic way was—and still is—frowned upon. So, while in the West we might use pictures of plants, animals, or landscapes to decorate homes and public buildings, people of the Arabic world often turned to calligraphy instead. In some cases the message being communicated by the calligraphy has been far less important than its decorative function, and calligraphers have produced work that is beautiful but practically indecipherable! There are examples of this in medieval Greek and Cyrillic too.

Before the introduction of paper in the 13th century, the principal writing material in medieval Europe was parchment (sheep or goat skin), which was both expensive and limited in supply. In the East, where the Roman Empire lived on in Constantinople—the New Rome—the classical culture survived because of the demands of an educated professional class, separate from the clergy. But in the West, production of books and documents was largely determined by the needs of church, state, and legal administration,

Above: Arabic script is often written for purely decorative effect, rather than to convey useful information.

Above: In Europe during the Middle Ages, calligraphers could become very rich producing decorative books for the wealthy. This beautiful design is based on the French Duke de Berry's Book of Hours—and reproduced as a project in this book (see page 94).

the latter also largely in the hands of churchmen (a "clerk" was originally a "*clericus,*" a member of the clergy). Non-church literature, whether in Latin or in the language of the ordinary people, was confined to a few centers of ecclesiastical learning and courtly culture.

Writing was therefore practiced mostly in the major monasteries and the chanceries of princes. The scribe was, like other artists, regarded as an artisan, a specialist craftsman, working as part of a team. It was common for a book to be written by several scribes working to a common standard, and unusual for the same man to be responsible for both writing and decoration (known as "illumination").

The introduction of paper allowed a much wider production of all kinds of writing, including the most highly decorated and sophisticated books, while parchment was kept for special works, such as luxury volumes for the wealthy, or for important documents intended to be long-lasting. The laws, or Acts, of the Parliament of the United Kingdom are still printed on parchment today and the earliest of these have survived for hundreds of years.

As the use of paper became more widespread, this was accompanied by a steady increase in the number of people who could read and write, both professionally and incidentally to their daily business. It was, however, in Italy during the Renaissance, the period at the end of the Middle Ages, that "the

scribe" truly became "the calligrapher."

The new movement in the arts extended to handwriting, with prominent individuals developing and popularizing a type of writing suitable for the new age. A landmark in this process was the publication in 1522 of the *Operina* of Ludovico degli Arrighi, the first printed handbook of calligraphy, and one of the most influential.

Meanwhile, another Chinese invention, movable type, was also having its impact on Europe. Printing in the Latin alphabet began in the 1450s, quickly followed by Greek, Hebrew, Cyrillic, Glagolitic, and Armenian. The first printed books were imitations of contemporary manuscripts, and could be illuminated by hand in the same way. The expansion in printing played an important part in the revival of classical literature, which also developed during the Renaissance.

The printers, in collaboration with contemporary calligraphers, began to revive classical forms of script for their typefaces. The printers' "Antiqua" is regarded as a "modern" typeface (as opposed to Black Letter Gothic, say), even though its origins are far older. This is because the typographers' immediate models were not Roman handwriting but Roman carved inscriptions, as these were the examples that had survived in greatest numbers. The most perfectly proportioned letters were considered to be those of Trajan's Column, in Rome, which celebrates the

victory by Roman Emperor Trajan (53–117 C.E.) over Dacia (now Romania).

In modern Europe the book has essentially been the printed work, and although "writing masters" continued to flourish, their status declined from that of the Renaissance calligrapher, and their skills became largely confined to the personal and practical sphere. It is noticeable that the dominant form of handwriting in 18th- and 19th-century England was Copperplate (see pages 114–117), whose name reveals its origins—a polished copper plate was engraved for use in printing—and demonstrates the pre-eminence of the press over the pen. With the invention of typewriters, a legible, standardized hand ceased to be necessary for the commercial clerk, and so the importance of handwriting diminished still further.

The Victorian rediscovery of—and interest in—medieval culture brought about a new appreciation of manuscript books, while the principles of the famous Arts and Crafts movement, which originated in England in the latter half of the 19th century, encouraged a revival of lost and dying craft skills that spread around the world as a reaction to the growing trend toward impersonal mass production. With the Kelmscott Press, founded by a leading member of the movement, the English artist, writer, and social reformer William Morris (1834–1896), there came a new focus on the book as a thing of visual beauty in itself. This trend, too, had an international influence.

The leading figures of the Arts and Crafts movement returned to medieval and Renaissance models—Morris used a "humanistic" or "Classical-style" hand for his private correspondence—and bequeathed to succeeding generations a renewed awareness of the importance of handwriting in the creation of letters. It is no accident that two of the most important figures in 20th-century typography were also artists: the sculptor and graphic artist Eric Gill and the virtuoso calligrapher Hermann Zapf. Their names are perhaps more familiar to the public as computer typefaces. In the present day the fact that most written texts are not handwritten has redirected our attention to the esthetic aspects of writing: to choose to write something by hand is to choose to create a particular visual impact, and more and more people are developing an interest in calligraphy and an appreciation of its potential.

At the same time, increased population movement and the ease of communications have made people increasingly aware of the calligraphy traditions of other parts of the world and awoken a desire in them to learn about and practice them. This book appears in fulfillment of that desire.

Professor Ralph Cleminson

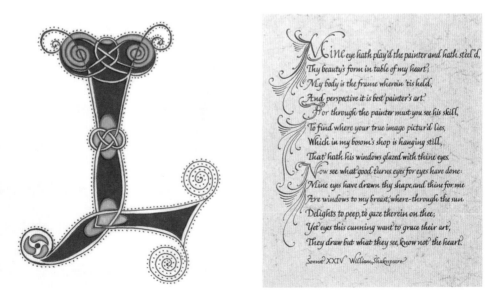

Above: Traditional illumination skills have been used in many projects found throughout this book as a celebration of the art of the calligrapher. The examples shown here are: Celtic rubrication (left) and Italic flourishes (right).

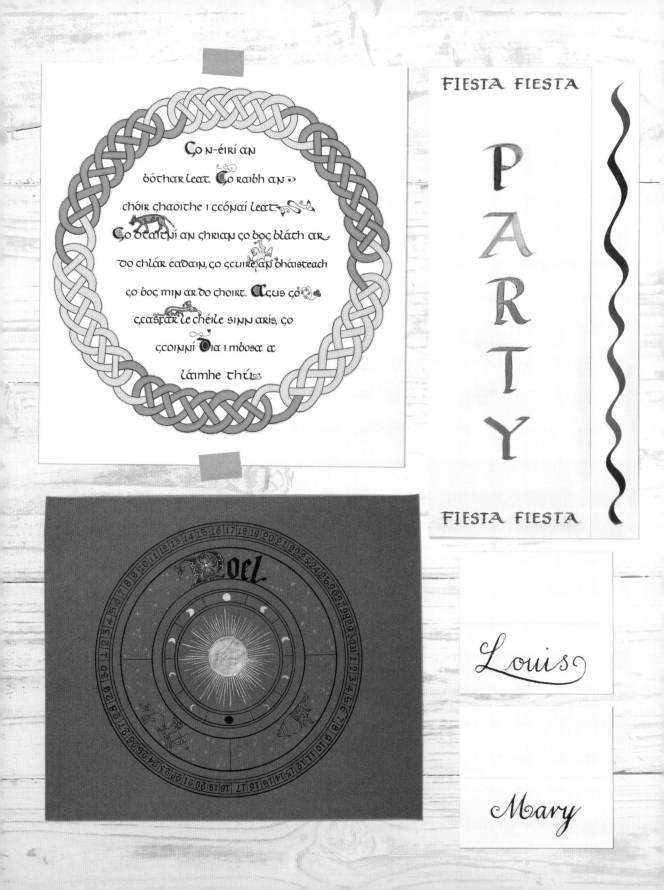

THE SCRIPTS

Unlike most arts and crafts, in calligraphy there's no long, tedious delay while you learn a series of complex skills. You can start right away—after all, you already know how to write! The art of calligraphy is all about honing the handwriting skills you already possess until you can produce truly stunning pieces of text. We will look at everything you need to know in order to do calligraphy, from the choices of paper, ink, and writing tools available—to how to hold the pen. The first script you will tackle is a form of Carolingian, known as "Foundation." It is chosen because of its elegance, simplicity, and natural, free-flowing style—ideal for beginners. Like all the styles covered in this book, Foundation is a Latin script. That means it is based on the Latin alphabet, which now forms the basis of texts in most European countries, and all the English-speaking nations around the world.

PENS AND NIBS

A wide variety of pens are used for calligraphy. The most ancient ones are bamboo and reed pens, which have changed little in the last 2,000 years. Later, dip-in pens appeared with interchangeable nibs ranging in size from the very thinnest, designed for Copperplate text, to chisel heads, for Black Gothic script. Modern additions are gel and fiber-tip pens. All are great for calligraphy.

Quill pens, cut from the flight feathers of a large bird, such as a swan or goose, have been used for centuries. They have a flexible nib, which gives them a natural feel and makes them wonderful to use.

Dip-in pens come in various shapes and sizes and are very versatile. They comprise a plastic or wooden pen holder, to which can be fitted a wide range of detachable steel nibs. Popular types include steel multi-line nibs, broad poster nibs, and Copperplate nibs. The choice of ink used with this type of pen is important to ensure they write evenly and smoothly without blobbing.

Nibs All nibs here are William Mitchell roundhand. They range from size "6," at 0.5 mm the smallest, to size "0," at 4 mm the largest. See the conversion table on page 128, which shows equivalents from other popular manufacturers. The small brass reservoirs are clipped to the underside of some types of nibs to hold the ink.

Felt-tip pens have fiber nibs and can be flat-edged for calligraphy. Some are double-ended, with different widths at either end. Fiber nibs are easy for beginners to use as you do not have to work with ink. But they lack the sharpness and precision of a steel-nibbed pen.

Ink Use bottled Fount India Ink. This should not be confused with "Indian Ink," which is not suitable for use with steel pens as it clogs the nib.

Other types of pens:

Bamboo and **reed pens** are cut and shaped at one end to form a point or a chisel nib. These have little flexibility when writing, but work well on various types of paper and fabric.

Fountain pens have a refillable reservoir and nibs of all shapes and sizes, including flat, chisel-edged ones ideal for calligraphy. **Cartridge pens** use handy ink cartridges, but the ink can be thin and watery.

WHAT TO WRITE ON

Paper and other forms of writing surface come in every conceivable size, thickness, weight, texture, and color. Their history is as long and varied as the pens used to write on them. The most ancient medium is papyrus, which is hugely resilient but can be very difficult to use. Other types of material include vellum and parchment. These are made from animal skins and, for the novice calligrapher, can be just as tricky as papyrus.

Vegetable parchment paper is available in a variety of weights and colors. It can have a slightly uneven texture that can enhance a piece of calligraphy.

Machine-made paper comes in a multitude of colors and textures and is available at most art stores.

White cartridge paper is a good type to use when beginning calligraphy. You can buy it in what is called an "art block" of 10 or 20 sheets. Always buy paper of good quality and thickness. If the paper is poor quality and is too thin, it will ripple when ink is applied to the surface.

Goatskin parchment paper is available in two weights—90 and 120 gsm. This type of material is known as "hot pressed," a process that gives it a smooth surface and takes ink very well, and so it is a good choice for calligraphy.

Parchment is made from sheepskin, which is a naturally smooth hide that is still used today for many important documents. Most suppliers do not carry real parchment, but rather parchment paper, which is a suitable substitute. Sheepskin parchment can, however, be special ordered at most retailers.

Papyrus is made from a reed plant that grows in Africa. Unlike paper, it is not smooth but has a cross pattern on the surface running lengthwise and widthwise, which gives it a coarse texture. The split reed stems are flattened and pressed one on top of each other, with the layers arranged at right angles. Reed or bamboo pens work well on papyrus.

Handmade paper can be a little more expensive to buy than machine-made paper but it is ideal for special pieces of work. It comes in many sizes, colors, and textures and usually has a watermark.

Watercolor paper gives an elegant look to calligraphy and color work. It has a rough texture that gives an attractive background for a free-flowing script.

COLORS, INKS, AND PAINTS

Other media, including pencils and color, can add a depth of beauty to calligraphy work. Pencil is especially useful when practicing. Colors add weight and strength to a piece and can be applied with a pen nib or painted on using a chisel-headed brush. Pigment, gouache, and watercolor all produce their own special effects.

Pencils come in a wide range of hardnesses. The softest are used in practice as they can be easily erased while the hardest are useful for transferring traced designs.

Small brushes are available in a variety of materials, ranging from synthetic hair to the finest Kolinski sable brushes. The best sizes to use are 000 to size 1. These have fine points, which makes them ideal for artwork such as Roman Capitals and illuminated (decorated) letters, and for painting fine lines and filling in hollow pencil-drawn letters.

Chisel-edged brushes work well for calligraphy on fabric, wood, and thick paper or card.

Double pencils are the ideal way to begin practicing calligraphy. They replicate the movement of a nib to show a script's form.

Poster color, also called tempra, can be used in a similar way to gouache, but does not produce such a professional finish.

Inks come in many shades, ranging from jet black to a translucent or pearly finish. Chinese Black ink is extremely dense and so is ideal for most forms of calligraphy work.

Pigment powders give a professional finish. They are in strong, vibrant colors and, unlike modern paint and inks, will not eat into paper or vellum. This means they will last for hundreds of years.

Gouache color paints come in all colors and even metallic shades, such as gold, silver, and bronze. They produce strong colors that are ideal for design and especially for illuminated letterwork.

MASTERING FOUNDATION SKILLS

ANATOMY OF A LETTER

All the strokes that make up the different parts of lowercase letters, and even some of the letters themselves, are given their own special names in calligraphy. Examples of the different types are shown on the right. They have all been written on lines using 7 pen-widths measurement.

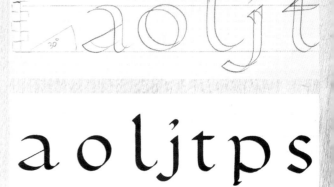

- The lowercase letter "a" has a **curved** stroke at the top and bottom and a **diagonal** stroke in the middle. The rounded part of the letter "o" is called the **bowl**.
- Tall, **upright** letters, such as "l" shown here, that go above the line are called **ascenders**. The letter "l" also has a short decorative stroke at the top, called a **serif**.
- Letters such as "j" and "p" that go below the line are called **descenders**.
- The letter "t" has a short horizontal line called a **crossbar**.

ANATOMY OF A NUMERAL

The same terms are also applied to the strokes that make up numerals. Examples are shown on the right, again using a measurement of 7 pen-widths between the lines.

- Number 1 is an **upright** stroke with a **serif** at the top.
- Numbers 2, 3, 4, and 7 have **diagonal** lines.
- Numbers 6, 8, 9, and 0 have a **bowl**.
- Number 4 has a **crossbar**.
- Numbers 2, 3, 5, 6, and 9 have **curved** stokes.
- As with lowercase letters, some numbers can be written above or below the line, depending on the type of script you are using. This can be a difficult technique to master.

HOLDING THE PEN

Try to relax your arm and shoulder when holding the pen. Right-handed writers should keep the pen in an upright position between the thumb and first finger, but with the first finger a little further down toward the nib. This will give you better control of the pen. The same applies to left-handed writers, except you may need to angle your paper to the right a little, instead of keeping it straight, to help you see the writing.

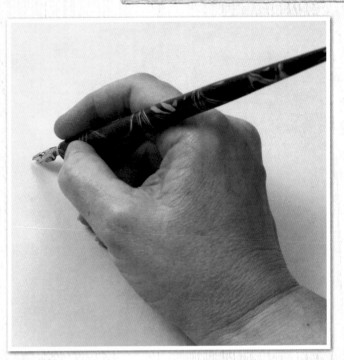

THE WRITING POSITION

It is important to have a writing slope. You cannot write with a calligraphy pen just working "flat" on a table, as you need to get the ink flowing at the right speed. Writing "flat" causes the ink to flow out of the pen too quickly. The angle of your drafting table can vary according to what you find a comfortable writing position.

A professional drafting table is a useful piece of equipment to own if you plan to spend time doing calligraphy. These can be bought from specialized art shops. Some are floor standing. Smaller ones sit on the table top. These drafting tables can be raised or lowered to different writing heights. They usually have a ruler attached at each side that can move up and down the board, which is very helpful when ruling up. However, they can be expensive.

An inexpensive option is simply to sit at a desk or table and place the bottom edge of a drawing board on your lap with the board itself against the edge of the table.

Another way to create a writing slope is to place some heavy books on the table and prop the board up against them. You can vary the height of the board according to the number and thickness of the books you use.

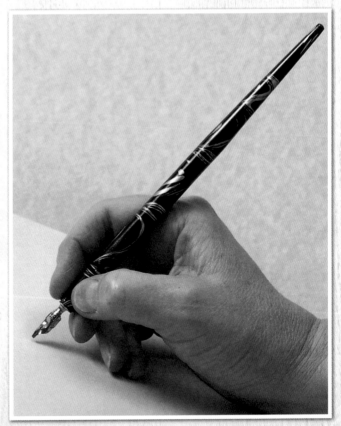

LOADING THE PEN NIB

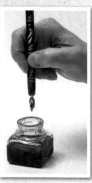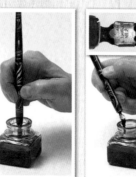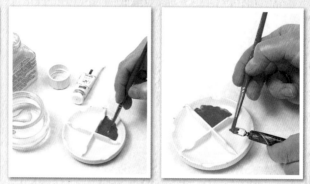

INK

When using ink from a bottle, dip the nib into the liquid until the ink has gone over the brass reservoir about two-thirds of the way down. This allows the ink to flow under the nib, to load it.

If you feel too much ink has been loaded you can take off the excess against the neck of the bottle.

GOUACHE COLORS

Loading a pen with gouache uses a different technique. First, squeeze some gouache color from the tube onto a palette. Add a little water and a drop of gum Arabic and mix to a watery consistency. You will need to try some practice strokes of the pen to get the mixture right.

Dip a size 3 or 4 brush into the gouache to load it. Hold the pen in your left hand with the reservoir uppermost, so you can see it, and stroke over the reservoir with the brush to transfer the gouache onto the nib. Scrape off any excess gouache against the side of the palette.

WRITING ANGLES AND PEN-WIDTHS

WRITING ANGLES

The angle at which you hold the pen nib against the paper depends on the script style you are writing.

For Foundation hand the angle of the nib to the top guideline for the writing is 30° (see below). This angle can make the letters fatter or thinner depending on the direction the pen is moving.

Uncial or Half-uncial script is written at as flat an angle as possible: ideally 20°. Many people find writing at such a flat angle difficult, however, and prefer to keep to 30°.

For Italic script you should use an angle of 45°. Gothic script is written at an angle of 30–35°. For Copperplate you should use an angle of 30°.

PEN-WIDTHS

The pen-widths used to determine the height of a letter also vary according to the nib being used and the script you are writing.

For Gothic writing, the pen-widths are 7 for capital letters and 5 for lowercase letters.

Italic writing has letters written at 7½ pen-widths for capitals and 5 pen-widths for lowercase letters.

Uncials are written at between 4 and 5 pen-widths. These letters do not have capital letters as such, so the script is written between two lines only. This will be explained later on in the Uncial section (see pages 72–77).

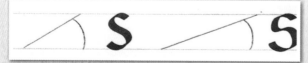

Placing the nib at an angle to the paper creates the thick and thin strokes that makes calligraphy script distinctive.

The angle of the nib varies according to the type of script you are writing and ranges from 20° to 45°.

PRACTICE STROKES WITH DOUBLE PENCILS

Once you have mastered the basic pencil technique, you can practice writing letters. Start by drawing a practice stave. Draw a line across the top of the paper. Measure down 10 in. (25.5 cm) and draw a line parallel to the first. Draw a line down the left side of your paper, measure 8 in. (20 cm) across and draw a second line parallel to this one.

Mark down your paper in pencil on the left side, as on page 25, and rule guidelines across the whole sheet.

Fasten your two pencils together using an elastic band. To make sure the points are level, hold the pencils upright and gently press the points down onto a flat surface.

Now you can practice the strokes shown in the examples below. As you practice keep the pencil points level and together, always maintaining the angle of 30°.

Practice writing just one letter for a few lines. Once you feel you are starting to master it, practice the next letter.

You will probably find that curves are a little more difficult to write than straight lines, but with patience and plenty of practice you will find they get much easier.

The more practice you put in at this stage, the easier you will find it when we come to write whole words and sentences in pencil, and later in ink.

Try writing these simple curved strokes using double pencils.

PRACTICE STROKES WITH A BRUSH

As an alternative to using pens, you can use brushes to paint calligraphy script. You use different sizes of brush according to the style you are writing: either wide brushes to create large flowing letters or small brushes for painting fine lines and textures, and for other detailed work.

It is a good idea to have a selection of good-quality brushes in your work box. If you look after them they should last for years. Sizes 4, 3, 2, 1, 0, 00, and 000 are very useful for most tasks.

The wide chisel-edged brush is used for very large letters and for writing a free style such as Italic script. For example, a ¼ in. (6 mm) chisel-edged brush made of ox hair is ideal as it is very soft and flexible to use. It can be used for writing posters, perhaps using gouache color, or writing decorative script on fabrics, using special fabric paints.

Try some practice strokes using the examples below before attempting complete letters. You use exactly the same grip for holding a brush as you would for a pen.

Then there are the fine brushes for intricate work. Brushes made of synthetic materials, such as nylon, are inexpensive and are good for mixing gouache color and for applying color to the nib.

Kolinski sable hair brushes are the most expensive, but are of great quality. They are lovely to use for fine work on illumination or when you need a fine line, for example when painting Versal-style Roman letters. Try practicing the brushstrokes in the example below to help you learn how to control the brush for fine work.

Start by practicing simple curves, taking care to show a clear distinction between the thick and thin sections of each stroke.

Now build up letters using these few strokes with variations.

PRACTICE STROKES WITH PEN AND INK

After you have mastered the basic pen technique, you can try letters. As before start by creating a practice stave. Draw horizontal lines 10 in. (25.5 cm) apart and vertical lines 8 in. (20 cm) apart. Measure all the way down the paper on the left-hand side and rule guidelines across. In the example below, the practice strokes are written with a Speedball size C2 nib (see page 128 for equivalents).

Practice these shapes, which make up the letterforms of the Foundation hand—also known as the Roundhand

script—until you feel confident with the pen. The more you practice the more confidence you will gain at forming the shapes.

Make sure the pen is held at a 30° angle to the paper and that your writing sits neatly on and between the lines.

Try to keep the pen high in your hand—taking care not to let it slip down—and aim to maintain an even pressure on the paper. The curved strokes are the hardest to do. Try to make them nice and round.

These are the basic straight-line strokes that make up a simple capital letter "A."

Combine the straight lines with a combination of curves to make up the capital letter "B."

Letters like the capital "C," which are made up mainly of curves, need more practice to master.

Keep the angle of the pen constant to achieve good Roundhand strokes with a thick nib.

CREATING A LETTER STAVE

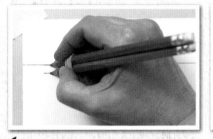

1 Start marking guidelines on your paper by ruling a line 1⅛ in. (3 cm) from the top of the paper. Now place the double pencils with the top point resting on this top line, ready to mark down the left side.

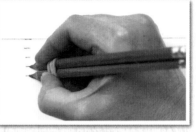

2 Now mark in pencil-widths down the paper. Here we are using 7 pencil-widths for capital (large or uppercase) letters and 4½ pencil-widths for lowercase (small) letters.

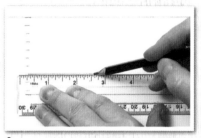

3 Rule a line across the page from the bottom pencil mark. This line is called the baseline.

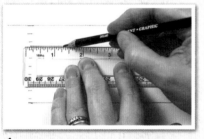

4 Count up 4½ pencil-widths from the baseline for the lowercase letters. Draw a line across from that mark. This is the x-line, the top line of the lowercase letters. The space between these lines is known as the x-height of a letter.

5 The top line (ruled first) is for capital letters and also for the lowercase ascender letters such as "d," "b," and "l." For the descender letters, such as "g" and "j," mark 3 pencil-widths below the baseline.

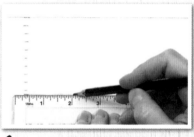

6 Now rule the bottom line. You should now have four ruled lines across your paper. When you become experienced at writing, this bottom line (for descenders) can be omitted.

top line
x-line
baseline
bottom line

7 Now use a protractor to draw an angle of 30° to your baseline. As you write, you should keep checking against this line to ensure your double pencils are at the right angle. After you have practiced you will be able to keep this angle automatically.

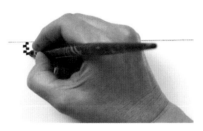

1 To rule up in ink, the pen is put at right angles to the paper and drawn sideways in steps, as shown.

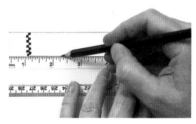

2 Draw the lines across as before in pencil—not ink, so that they can be erased at the end of the project.

PREPARING TEXT FOR LAYOUT
AND PLACING BORDERS

LAYOUTS

When you start ruling up it is important to mark guidelines and measurements using a soft 2B pencil. Make sure you press lightly on to the paper, as you will want to rub out the lines after applying the ink—you do not want them to show on the finished work. There are many ways of laying out your writing on a page, including the six examples shown here.

The easiest way is to work to a left-hand margin. To do this, first rule a line down the left-hand side of your paper. This line marks your margin, which could be 1–2 in. (2.5–5 cm) from the edge of the paper, for example. Working down this margin line, mark three or, if needed, four guidelines for each line of writing. Rule these lines—your baseline, x-line, top line and, if needed, bottom line—across the page (see Creating a Letter Stave on page 25 for complete details on how to mark and rule guidelines).

Another interesting design is to stagger your work, which means one line starts at the left margin, the next line starts, for example, 2 in. (5 cm) in from the margin, then the next one at the margin again, and the following line indented as before, and so on down the page.

For a different look you can center your lines of writing. Start by writing out your lines on a rough piece of paper. Now, measure each line in turn and halve the measurements. Draw a center line down the middle of your final draft. Mark where each writing line will be placed and then work down the paper, transferring the measurements you made and putting a pencil mark to show where each line of writing will start and finish.

Once you have pencilled in the marks, it is a good idea to write out your lines again in pencil, just to see how they will look, before attempting the final draft. This can be a difficult procedure to get right, but it creates a very attractive design to work with.

Circular writing also looks good and makes a change from the standard straight layouts, although you should bear in mind that it can be difficult to read those words that appear upside down.

Spiral layouts are complex but also more interesting to look at. This layout works especially well with Uncial scripts.

You can also write freehand where no guidelines are used on the page. Patterns can be made by using the letters as designs. Some modern calligraphy is written this way, but it takes an experienced hand to write like this.

Another technique is to cut out each line of text, arrange it on the page, and then stick it down, once you have it correct. This method is often known as "paste-up."

If you try this with rough paper to start with it will give you a good indication of where your writing will begin and end and allow you to make changes. You'll also be able to see what the finished work will look like.

Using a simple left-hand margin leaves room for an eye-catching motif.

Staggered designs can be decorated with motifs and illuminated letters.

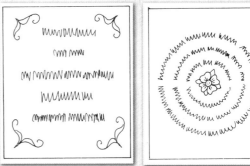

Centered layouts work best for short, memorable pieces of verse, quotations, or sayings.

Circular writing works best around a central motif to draw the eye.

Spiral writing needs a lot of planning, but the result is well worth it.

Free-hand layouts allow calligraphers much more freedom of expression.

PLACING BORDERS

Adding a border to your writing will enhance the whole page, especially if you are using color. There are many types of borders, from simple corner motifs, to margin decorations, to borders that go all the way around the page.

To start, place tracing paper over your writing page and attach it to the corners using masking tape. Decide what type of border you think looks best for your piece of work, then measure the space where the border will start. Draw two lines on the tracing paper for the border to fit into, allowing you to sketch the pattern directly onto the tracing paper. Now draw your design. Remove the tracing,

turn it over and rub lightly on the back with the side of a soft 2B pencil. Now turn the tracing over again, attach it once more and, using a hard H pencil, draw over your pattern to transfer carbon to the paper below. This is called "carbonizing." When you have finished, remove the tracing.

Now that you can see your design on the paper, you may need to draw over what you have traced to make it clearer. Use a light touch with a soft pencil. You can then ink it in, using a pen or a brush. You might like to add color to the design, or outline the pattern with a fine-line black pen.

With some designs you may need to draw the borders and other pieces of decoration first, and then write the text afterward.

More elaborate designs will need lots of planning. Write the text in pencil first and measure each line, so that you know how much space to allow.

Common mistakes, tips, and problem solving

Two examples of the word "pascal" have been written to show the difference between good and bad spacing.

The first figure shows:
- There is too much space between the "p" and the "a," and between the "a" and the "l."
- The letters "a" and "s," and "c" and "a" are too close.
- Most letters need to have even spacing—but there are

exceptions to this rule. For example, when writing "t" and "r" or "a" together, you can write them with less space between.

The second figure below shows how the word should be written with even spacing.

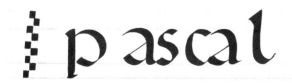

Uneven spacing between the letters.

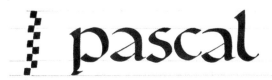

Evenly spaced lettering.

CHAPTER 1: *CAROLINGIAN*

This script is often called Roundhand because it is a round script with open spacing, which makes it easy to read. It is also known as Foundation hand because it is the script taught first to students. The double-pencil practice method shown here allows you to see how to construct the letters, and where you start and finish each letter.

DOUBLE-PENCIL MINUSCULE

Writing with two pencils allows you to create a much larger letter, and it is much easier to see which letters in the alphabet go above and below the ascender and descender stroke lines.

You will find using a pencil to start with a great help to your writing. Most importantly, using two pencils allows you to practice how to keep to the correct writing angle, which varies according to the script you are writing. Carolingian script is always at 30°. Here we are starting with the lowercase letters—known as "minuscule."

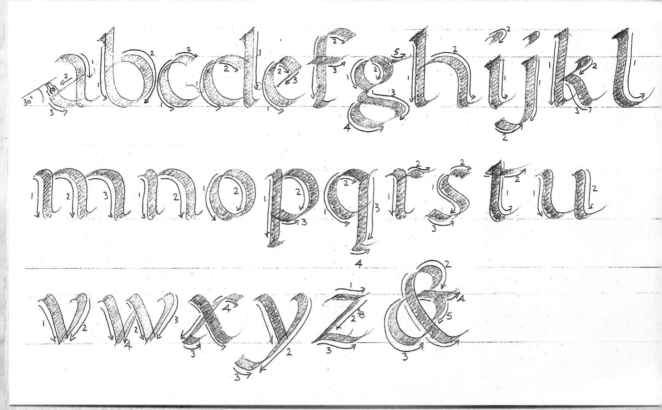

Follow the sequence of strokes indicated by the arrows to write each letter.

HOW TO START USING TWO PENCILS

You may ask why do we start learning calligraphy with double pencils? There are several good reasons for this. First, it helps the student see the formation of the letters—to look through them, if you like—and see how they are made. Double-pencil work also helps you to keep the angle of the writing correct and lets you see where you start and finish each letter. You can also see your mistakes more easily.

Writing with two pencils also allows you to draw a much larger letter. The largest letter that can be written with a steel nib is still much smaller than one you can achieve by using double pencils. This method also shows in easy steps which strokes go above the x-line (ascenders) and which go below the baseline (descenders).

You may find it easier to fasten the two pencils together using an elastic band.

The fact that you are not using a pen at the start and so do not have to concern yourself with using ink is a great help, as this allows you to concentrate on the letterforms. Ink can be hard to control with a steel nib when you begin calligraphy work.

Later you will discover that the skill of using the pen is in applying the right pressure. If you press too hard, the steel nib may open and allow too much ink to flow down the nib onto the paper. This can result in blobs on the letters, and the letters can become too fat. If you do not apply enough pressure then too little (or no) ink flows onto the paper, which can be a frustrating start.

RULING UP

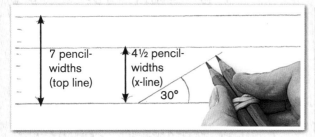

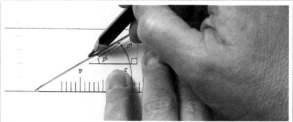

Make sure your writing position is correct. Keep your feet flat on the floor and your back straight.

After drawing a top line across the paper, hold your double pencils in an upright position on the left-hand side of the paper. Now touch the pencils onto the paper leaving a small pencil line. Mark down the side of the paper in this way to give 7 pencil-widths and draw a baseline. Now measure 4½ pencil-widths and draw another line along your paper. This gives you your x-height for the main body of this lowercase script and for starting the letter "o."

Carolingian script is always written at 30°. Use a triangle (above) or a protractor to draw an angle of 30° on your baseline. Place both pencils at the top of the 30° line to find the correct writing angle. As you write remember to keep checking that the angle is correct. Now start writing the letter "o" (below).

WRITING THE LETTER "O"

Keeping your pencils at the 30° angle, place the uppermost pencil on the x-line (the top line at left) and draw a curve to the left side and down to the baseline and stop.

Go back to the top of the stroke, where you started from before and, again keeping the 30° angle, draw a curve to the right side, down to meet the bottom of the "o."

To ensure that a script is even, you must keep all the thick downstrokes slanted consistently at the correct angle for that script. Try to give the letter a nice round shape. Repeat writing this letter to the end of the line. Practice this until you have written five lines of the letter "o."

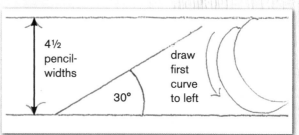

CONSTRUCTION OF THE LETTER "W"

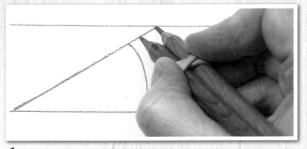

1 Create a stave (see page 25) for lowercase letters and use a triangle or protractor to draw in the 30° marker for the pencil angle.

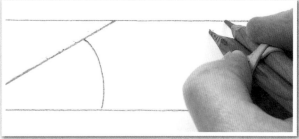

2 Place the double pencils on the page at the angle shown in the stave and with the upper pencil touching the x-line.

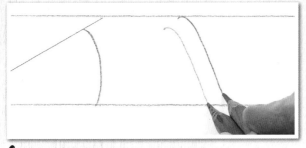

3 Keeping the angle of the pencils constant, sweep them slightly to the right and then bring them down until the lower pencil touches the baseline.

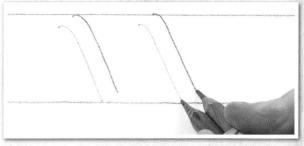

4 The second stroke replicates the first. Take care to leave the correct spacing so that the joining stroke is neither too steep, nor too flat.

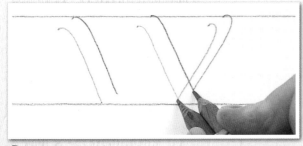

5 Make the outer stroke next. Start from the same position but curve the pencils sharply to bring them back to the base of the second stroke.

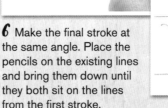

6 Make the final stroke at the same angle. Place the pencils on the existing lines and bring them down until they both sit on the lines from the first stroke.

CONSTRUCTION OF THE LETTER "G"

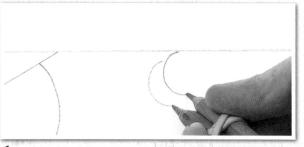

1 The "g" is a more complicated letter, made up of curves. Start with the top pencil on the x-line and sweep the pencils around, finishing in the middle of the stave.

2 Take the pencils back to the starting point and bring them around to the right to join up with the first stroke.

3 Begin the tail of the letter at the finishing point, and sweep the pencils left and then right along the baseline.

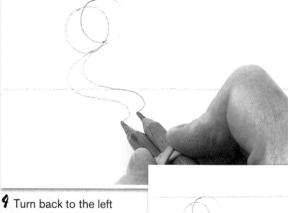

4 Turn back to the left before enclosing the bowl with a stroke from the left to the right of the tail.

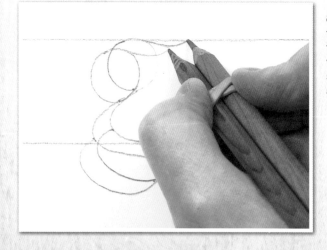

5 To make the final tail at the top of the letter, place the pencils back at the very beginning point and sweep them to the right along the x-line.

CONSTRUCTION OF THE LETTER "S"

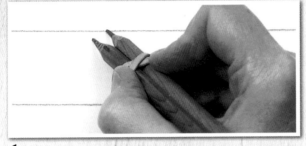

1 The "s" is made up of mirrored curves. Start the main body of the letter in the same place, with the upper pencil on the x-line.

2 Sweep the pencils down to the left, across to the right, and back to the left until the lower pencil sits on the baseline.

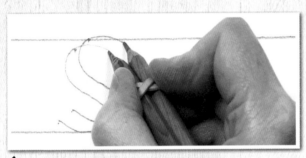

4 Finish the letter at the top by placing the pencils back at the start point and sweeping them to the right. You can enclose the ends with a tick from a single pencil.

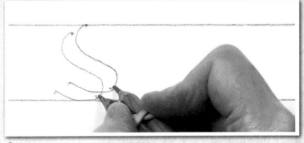

3 Make the bottom of the letter by bringing the pencils back to meet the end of the previous stroke.

CONSTRUCTION OF THE LETTER "J"

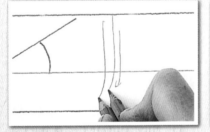

1 Check your writing position is correct. Keep the pencils at 30° and start at the x-line, as before. The "j" has three strokes. Write the first stroke by pulling down, stopping just above the bottom line.

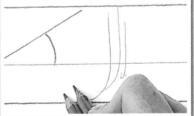

2 Follow the directions of the arrows to complete the second stroke. Return to the top of the first stroke, again finding the 30° angle with pencils to the x-line, and draw to the right to join the first stroke.

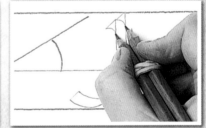

3 Return to the top of the letter and find the angle. Now draw the serif, pulling slightly to the right, before joining the main body of the "j."

CONSTRUCTION OF THE LETTER "O"

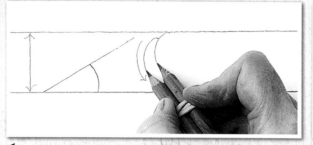

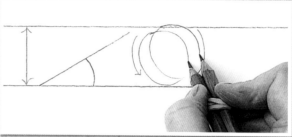

1 Keep pulling the pencils toward the baseline, and finish the curve by drawing the remainder down toward the right. Pull the pencils off as soon as you reach the baseline to complete the first stroke. The "o" has two strokes.

2 Return to the top of the stroke, and again find the 30° angle with pencils to the x-line. Now draw a curve downward to the right side, moving left, and coming off the paper as you cross the baseline. Practice the "o" five times.

Common mistakes, tips and problem solving

A common mistake when starting with this Foundation hand is in making the round letters too narrow. They need to be wide and rounded. The letters "b," "c," "d," "e," "g," "p," and "q" are all based on the letter "o."

The letters "h," "m," "n," and "u" are also written with wide spaces between the strokes.

Beginners also tend to not leave enough space between the downward strokes.

Another common mistake when starting to form the letters is failing to keep the 30° angle. Keep checking the angle as you write. After writing a few letters, go back to the 30° angle diagram on your paper. Place the pencils on the angle line. Keeping the right angle of the pencil (and pen) is one of the hardest things to master.

Changing the angle to form some of the strokes in the letters takes a bit of practice too. These changes occur in the letters "a," "f," "t," "v," "w," "x," "y," and "z." You will

need to flatten the angle to draw them correctly. If you do not change the nib angle these strokes will look too fat and you will not have the right weight of letter.

The curve of the "s" can also be difficult. Try writing lots of "s" practice strokes without the top and bottom curves. The practice stroke page really does help you with the formation of all the letters.

Try to keep your concentration on the example of the lowercase letters when you are copying the alphabet. Study how the different strokes make up each letter. Look at the directional arrows, too, so that you know the order in which to draw the strokes.

Keep even spacing between upright strokes like those in the "h," "m," "n," and "u." A common mistake is to allow too little—or too much—space between them.

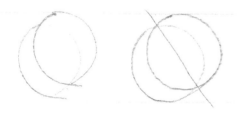

The "o" on the left is too upright, with unclear joins, while the letter on the right is perfectly circular.

The "d" on the left has been drawn with badly angled pencils, giving unclear crossovers and joins.

DOUBLE-PENCIL MAJUSCULE

The double-pencil method is a good way to practice the Carolingian majuscule, or capital, letters. These are slightly different to construct than the lowercase letters and a little more difficult to draw, but the same basic principles apply as before.

Carolingian majuscule letters are based on 7 pencil-widths between the ruling lines. As with the minuscule, or lowercase, letters it is easier to understand how the letters are constructed when using double pencils, which is an important advantage at this early stage.

The only letters formed with curved strokes are "B," "C," "D," "G," "O," and "Q." These are wide, round letters.

Remember to sweep the pen nib around with even pressure. All the rest of the letters are formed with straight-line strokes. The letter "M" is the most difficult letter to construct, as it is made up of five different strokes.

You still need to keep the 30° angle when writing the capital letters. This gives you the right weight of the letter stroke.

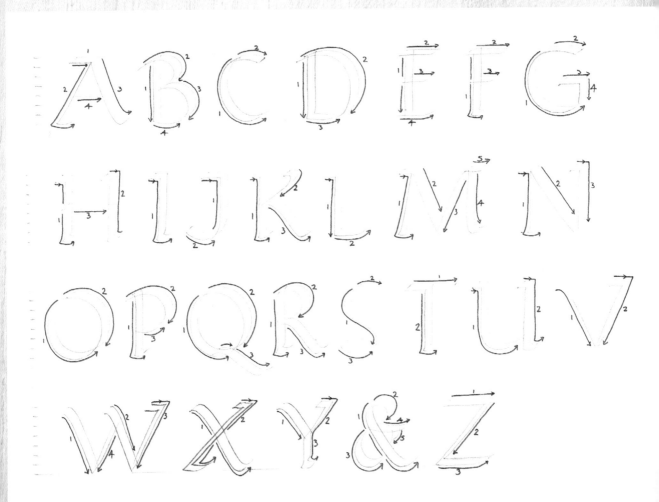

Use the stroke sequence arrows to complete the alphabet.

CONSTRUCTION OF THE LETTER "A"

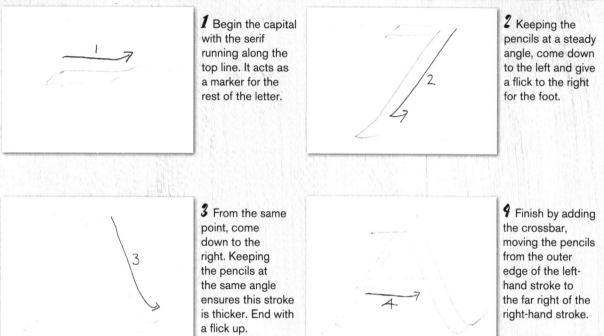

1 Begin the capital with the serif running along the top line. It acts as a marker for the rest of the letter.

2 Keeping the pencils at a steady angle, come down to the left and give a flick to the right for the foot.

3 From the same point, come down to the right. Keeping the pencils at the same angle ensures this stroke is thicker. End with a flick up.

4 Finish by adding the crossbar, moving the pencils from the outer edge of the left-hand stroke to the far right of the right-hand stroke.

CONSTRUCTION OF THE LETTER "M"

1 Repeat the first stroke of the "A" at a slightly less steep angle.

2 Follow by bringing the pencils down from the very top line, but leaving the base open to be joined.

3 Allow the third stroke to have slightly more movement and flow than the first.

4 The right-hand stroke is more vertical than the second and ends in a slight flick to the right.

5 Finish with a straight serif along the top line.

DIFFICULT MAJUSCULES

The majuscule letter is more difficult to draw than the minuscule, both because of its size and because it is made up of lots of straight lines. It can be difficult to keep the pen controlled and ensure that the form of the letter does not become uneven. The examples given on these pages show the most problematic majuscule letters to draw.

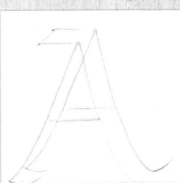

The "A" has two diagonal strokes that need to be spaced correctly: not too narrow, but not too wide either.

Practice the body of the "S" several times before trying to complete the letter. The second and third strokes can be over the topline and below the baseline.

"E" and "F" are both made up completely of straight lines.

Flatten the angles of the horizontal strokes, reducing their weight, so that they do not look too heavy.

"W" is made up of four strokes. The two diagonals to the left are narrower than the others. The angle is slightly flattened.

"M" is the most difficult letter to write as it is made up of five strokes and the stroke angle changes several times in the course of construction, with the first and fourth strokes ending with an outward move.

"X," "Y," and "Z" are all constructed in the same way from a mixture of straight strokes. The diagonal stroke to the left of the "X" has a flattened angle, as does the second diagonal stroke of the letter "Y." With the "Z," all the angles must be written with a flattened angled pen, otherwise it will look too heavy on the top and bottom strokes.

Common mistakes, tips, and problem solving

- The majuscule Carolingian alphabet is more tricky than the lowercase version as the letters contain more strokes, requiring a steady hand and unhurried movement. Keeping the pen controlled is the absolute key.
- If you do not write with confidence, the letters tend to wobble as you write the downstrokes, and the bowls of the letters become uneven, requiring various angles to ensure they meet at the correct point, rather than keeping the lines straight.
- Problems can also occur when writing the round letters. The most common mistake when starting out is not making the bowls of the letters rounded enough. In the letter "B," for example, the bowls of the letter (the second and third strokes) need to be very rounded, but most beginners compromise on these strokes by making them too narrow, giving the letter a rectangular appearance that doesn't fit the bold roundedness required of the hand.

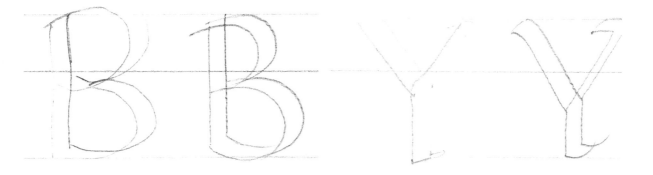

Write with confidence to keep the lines straight and the curves meeting in the correct position.

The pencils must remain at the same angle to the page, whatever the direction of the stroke, to retain evenness.

DOUBLE-PENCIL NUMERALS

Writing numerals is no different from writing letters in roundhand. Use the full height of the stave, noting which numerals dip a little below the baseline. Ensure the lines that make up straight strokes are parallel, and draw curved strokes with a fully rounded sweep.

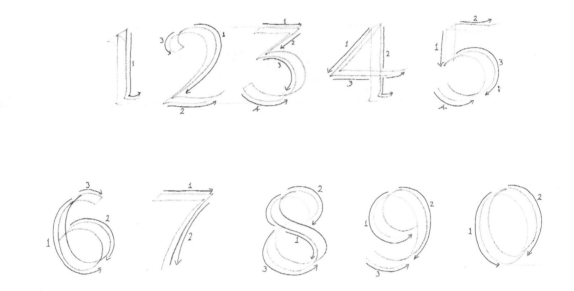

Use the stroke sequence arrows to complete the set.

WRITING A YEAR DATE

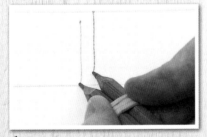

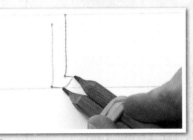

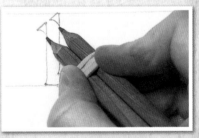

1 Create a full stave and draw in the angle, if required. Start the "1" with a crisp vertical stroke.

2 At the bottom, turn to the right to give the numeral its foot, and enclose the stroke with a tick.

3 Place the pencils back at the starting position and draw two little triangles to form the serif.

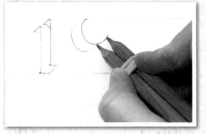

4 The "9" starts at the top line, with a tight, counterclockwise curve.

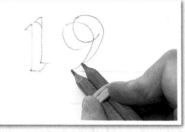

5 Return to the start to make the main body of the numeral.

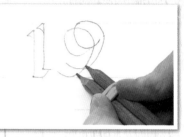

6 Finish by bringing the tail of the "9" back to the bottom of the numeral.

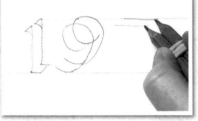

7 The "7" is made up of two strokes, the first running directly along the top line.

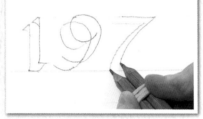

8 Bring the tail down in a long sweep that opens out toward the base of the "7."

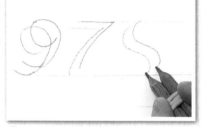

9 Start the "8" like an exaggerated "S"—with the top and bottom openings near the vertical.

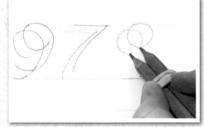

10 Enclose the top bowl as before, bringing the pencils down to the first stroke.

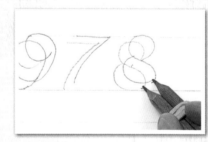

11 Finish by enclosing the bottom bowl, moving to the right from the first stroke to the bottom of the numeral.

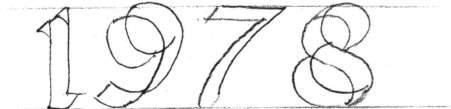

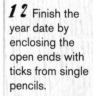

12 Finish the year date by enclosing the open ends with ticks from single pencils.

USING THE PEN: MINUSCULE

Once you feel you have gotten as far as you can using the double-pencil method, it is time to start to write the Carolingian script using pen and ink. It may take a little practice just to discover the right amount of pressure to use but you will soon get a feel for it.

Start with a Speedball size C1 nib (see page 128 for equivalents from other manufacturers). This is the largest and easiest to practice with. Using a pen can be difficult to master at first after writing with double pencils, as the letters are smaller and the ink is more difficult to control.

Place the reservoir just below the tip of the nib, up to ⅛ in. (3 mm) is fine. If it is too close to the end of the nib it may touch the paper when you start to write. If it is too far back then too much ink will flow down the nib and the letters will be too thick. Try the practice strokes first to learn how the letters are formed. When writing lowercase, try to keep the letters flowing with an even pressure. The letters should have a good rounded appearance.

Keep the nib at a 30° angle all the time. As you are moving the pen over the page to form the letters, the angle must remain constant. Keep checking throughout the writing of the alphabet. Make space between the upright strokes and keep them wide and even.

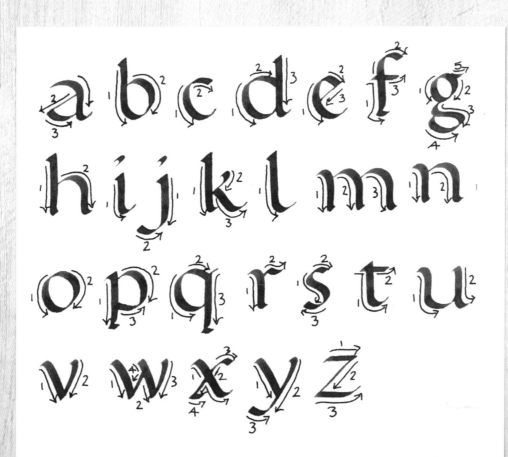

Use the stroke sequence arrows to complete the alphabet.

HOW TO DRAW ASCENDERS

1 **For the letter "b,"** put the nib under the top line. Draw the pen down the paper in a straight line. Before the bottom, curve to the right in a wide stroke and stop.

2 Put the nib onto the stroke a little from the top. Draw the pen up and over into a curved stroke. Go down to meet the first bottom curve. This makes the bowl part of the letter.

3 To make the serif, put the nib on the top of the letter at a 30° angle. Go slightly to the left and then down to the right to meet the straight part again with a little movement.

1 **For the letter "f,"** put the nib on the top line at a 30° angle. Draw down the paper to the baseline. Now go slightly to the left and then to the right, drawing the pen across on the line.

2 Put the nib back onto the top of the letter and, with a sweeping curve stroke, draw the nib to the right in an arc.

3 To make the long crossbar of the letter, put the nib to its left, just below the x-line. With a slightly flatter pen angle, draw the nib across, keeping it level to the right and stop just below the curved line of the "f" above.

HOW TO DRAW DESCENDERS

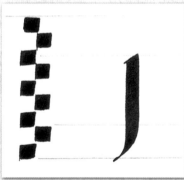

1 **For the letter "j,"** start at the x-line. Keeping the pen at a 30° angle, draw the pen down the paper. Keep an even pressure. Before the bottom line, curve a little to the left and stop.

2 Put the pen to the left and draw the nib to the right in a curve, to meet the first stroke.

3 Place the nib on the x-line and make the serif by going to the left slightly and then to the right in a diagonal stroke to meet the straight downward line.

4 To make the dot, place the nib on the paper above the top of the letter. Curve the nib to the right in an arc and then make a small curve to the left.

HOW TO DRAW COMPLICATED LETTERS

1 For the letter "q," put the pen on the x-line at a 30° angle and draw the nib around to the left in a curving stroke that touches the baseline and then sweeps up.

2 Go back to the starting point. In a curved stroke to the right, move the nib in a slight arc and stop.

3 Place the nib on the end of the previous stroke and draw the nib straight down to below the baseline to form a descender.

4 Put the nib on the end of this downward stroke and draw the nib across to the right to form the final serif line.

1 For the letter "g," put the pen on the x-line and draw the nib to the left to form a small curve two-thirds of the x-height, and then stop.

2 Move back to the top and curve the nib right and down to meet the bottom of the first stroke. This forms the small bowl in the shape of an "o."

3 Place the nib on the bottom left curved line. In an "s" curve below the baseline, draw the nib across to the right and then left and stop.

4 Now place the nib onto this "s" curve and sweep the nib to the right in a curved stroke to meet the third stroke. This forms a rectangular shape.

5 The last stroke is the small sideways serif stroke at the top. Place the nib at a 30° angle and draw the nib to the right a little just below the x-line. Stop.

1 For the letter "w," place the nib on the x-line. Keeping the pen at a 30° angle, sweep down diagonally to the right-hand side with a slight curve and stop at the baseline.

2 Repeat the first stroke, but spaced to the right a little.

3 The third stroke joins the second stroke. Angle the pen slightly flatter, put it on the x-line and move diagonally down to the left to meet the base of the second stroke.

4 To finish, place the nib a little way down on the middle stroke (drawn in step 2). Angle the nib flat again and draw down to meet the first stroke on the left at the bottom.

1 For the letter "m," put the nib on the x-line. Keeping the nib at a 30° angle, arc up a little, then curve down. Before reaching the baseline, go slightly to the right. Stop.

2 Put the nib on the stem of the first stroke. Curve to the right and down to the baseline, as in step 1. Finish with a slight curve to the right. Ensure there is a wide space between downstrokes.

3 For the third stroke, put the nib on the second stroke and curve right. Now go down to the base. Finish off with a slight curve to the right. Ensure there is equal space between all three downstrokes.

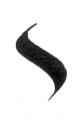

1 For the "s," put the nib on the x-line. Sweep down to the left, curve to the right, curve to the left again, and end at the base.

2 Now go to the top of the first stroke and curve to the right in an arc and stop.

3 Take the last stroke down to just above the baseline. Sweep to the right in a curve to meet the first stroke.

1 For the letter "x," put the pen on the x-line. With even pressure, draw a diagonal line to the right down to the baseline.

2 Put the pen on the x-line to the right of the first stroke. Turn the nib to the right to make a flatter angle. Draw down to left. Stop just above the line.

3 Place the nib on the baseline and draw it a short way to the right to make the serif.

4 To finish the letter, place the nib back on the x-line and curve the pen to the right in an arc stroke.

1 For the letter "z," start by putting the nib just below the x-line. Use a flatter angle otherwise it will look too heavy. Draw the nib to the right along the line keeping the pen straight.

2 Take the nib back to the x-line at the right side. Turn the nib slightly to the right and flatten the angle again. Draw a diagonal line to the left. Stop at the line.

3 From where the last line finished, place the nib on the paper and draw it across to the right, along the baseline. Stop.

PEN MAJUSCULE

Creating the Carolingian majuscule (or capital) letters requires even more practice. As with the double-pencil method (see pages 34–37), check that the angle of the pen remains at a constant 30°. Always write with confidence and remember that some of the letter strokes are written at strange angles. Keeping these angles correct ensures that the letters always have the right thickness and so will always have sufficient "weight" on the page.

When writing capital letters, make the curved letters rounded and open, especially "B," "C," "D," and "G." There are quite a few angle changes in letters of the majuscule alphabet, particularly the "V," "W," "X," "Y," and "Z." You use the same basic techniques you practiced when writing lowercase letters with a pen (see pages 40–43).

Try some practice strokes using your largest nib (refer to page 128 for nib sizing). Look at the arrow sequences shown on the letters below to help you follow the right direction of the pen when forming the letters. Always pull the pen—if you find yourself pushing you will probably smudge the ink and can even break your nib.

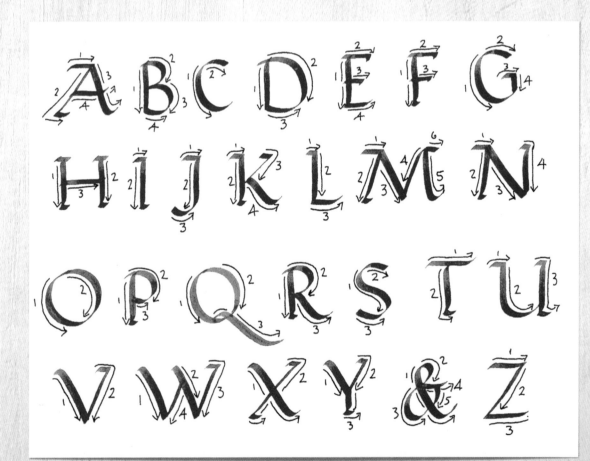

Use the stroke sequence arrows to complete the alphabet.

PEN NUMERALS

When writing numerals in pen you should follow exactly the same techniques as for the capital alphabet. Use the full letter stave (7 pen-widths), keeping your pen at the same 30° angle throughout, and follow the stroke sequences shown below to build up each number. Numerals are generally plainer than the letters, with fewer serifs. But all follow the same general rules, with the bowls full and generous, and the straight lines solid and well-defined. Numerals are not often used, but they can appear in unexpected places!

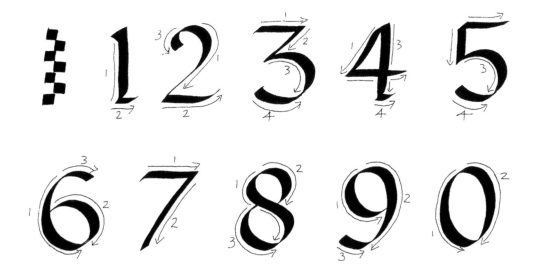

Use the stroke sequence arrows to complete the numerals.

WRITING THE NUMBER "3"

1 Place the pen at a 30° angle along the top line and pull to the right.

2 Keep the same angle to draw a sharply defined diagonal stroke down to the left.

3 Ensure the numeral's bowl is full and well-bodied, breaking out to the right of the top stroke.

4 Finish by completing the bowl, highlighting the end with a small tick.

PROBLEM COMBINATIONS

Certain combinations of letters, known as ligatures, have to be written with particular care to avoid some of the strokes clashing in a messy way.

The most common examples of these are "tt," "ft," "ff," and "fl." Other problem combinations include capitals and ascenders, such as "Th" and facing letters like "ra."

Common writing errors are shown at the bottom of the page. To make it easier on yourself, try to concentrate on the example of the lowercase letters when you are copying the alphabet. Study how the strokes make up each letter and look at the directional arrows too.

Maintain even spacing between upright strokes such as those of the "m," "n," "h," and "u." A common mistake is to allow too little or too much space between letters.

Bring the second "t" to the left and use a single crossbar.

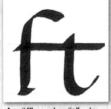

An "f" and a "t" also share a crossbar.

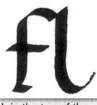

Join the top of the "l" to the end of the "f."

A second "l" should be taller than its predecessor.

Start the arc of the "a" from the end of the "r."

The "h" will also break into the crossbar of the capital "T."

All the punctuation marks, including question marks and colons, sit more closely to the preceding letter than would another letter.

A second "f" should also be taller, and also a little narrower.

common mistakes, tips, and problem solving

The example word "montreal" (below) has been written to show examples of common errors made by beginners in calligraphy. Compare this version with the correct one (below right). As well as problems with the individual letters, overall spacing is inconsistent.

- The "m" is not written with even spacing between the upright strokes.
- The "o" is too thin and needs to be more rounded.
- There is too much space between the upright strokes of the "n" and its feet do not sit parallel on the baseline.
- The bottom curves of the "t" and "r" are too extended.
- The two curved strokes of the "e" are not rounded enough.
- The "a" is not wide enough at the top and bottom.
- The "l" is too short at the bottom—it should curve around further.

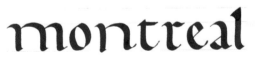

Every letter shows a problem.

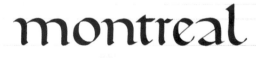

Every letter is written correctly.

HOW TO CREATE A SIMPLE ILLUMINATED LETTER "L"

1 To construct guidelines, draw a box shape 2 in. (5 cm) square using a soft 2B pencil. Draw the letter to be painted inside this box using a very light touch.

2 Now paint a thin outline. Using a size 000 sable brush, take some color and very carefully paint around the whole letter with a single outline just inside the pencil line.

3 Finally, take a size 1 sable brush and fill in the rest of the letter. Float the color up to your painted thin outline. Try not to go over the line.

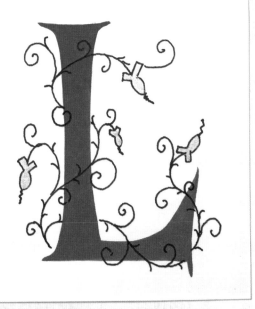

4 Now you can add the attractive foliage decoration. When the paint is completely dry, use a soft 2B pencil to draw your leaf and vine design over the letter. Now use a black fine-line pen to go over your pencil lines. Paint the leaves by filling inside the black outline. You can make the leaves all black or add another color to the leaves if you wish. When the black is dry, rub out your pencil lines, if they show.

illumination tips

Drawing decorated letters is known as illumination and is an ancient craft practiced by medieval scribes. The technique is shown in the steps above.

Drawing over the painted letter with a black fine-line pen is a simple way to create decoration.

It is always a good idea to draw the design in pencil first as a guide and then go over it in black ink. Always wait for the color to dry completely, otherwise the ink from your pen will bleed into the color.

Start with a soft 2B pencil and adopt a light touch as you do not want to see the pencil line beneath the color.

In step 2 above, use long, thin, flowing strokes in a smooth movement to give a crisp color outline.

When filling in with color in step 3, try to float the color over the infill of the letter. Load the brush with plenty of paint and fill in the letter as quickly as possible. This gives good opacity. Try not to let your brush get too dry as this leaves brushstrokes—a common mistake.

Mixing the Gouache

Take a tube of gouache color and put a small amount in a palette. Using a size 3 brush, mix in a drop of gum Arabic and a little water until it is the consistency of light cream.

Birthday cards

It can be difficult to find a message for special occasions that will be truly appreciated, especially in today's "throwaway" world. Carolingian script was developed to add "weight" to words, not just to communicate. Creating a birthday card for a friend keeps this tradition alive.

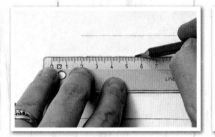

1 To make the rough practice draft, rule guidelines on half the practice cartridge paper. Use 7 pen-widths for the top line, and 4½ pen-widths for the x-line.

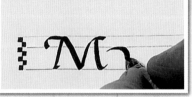

2 Practice the phrase in ink until you are satisfied with it. For the six strokes of the majuscule "M," see the capital stroke alphabet on page 44. For the lowercase letters, see the stroke alphabet on page 40.

3 Use the spacing instructions on page 27 for the remainder of the phrase. Measure the finished words to make sure they fit onto half the front of the envelope.

Materials

Practice cartridge paper
Sheet of tracing paper
Sheet of 8½ x 11 in. (21 x 28 cm) parchment paper
Card stock and matching envelope
2 Speedball size C3 nibs
2 penholders
2 reservoirs
Soft 2B pencil
Gold marker pen
Chinese Black ink or Fount India ink
Ruler and triangle Eraser
Black fine-line pen

For color work
Red gouache color
Gum Arabic
Size 4 paintbrush
Palette and jar of water

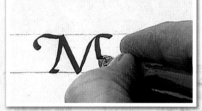

5 Use the brush to mix the red gouache on the palette with a few drops of water and one drop of gum until the paint has the consistency of single cream. Load the pen (see page 22) and create the "M" as in step 2.

4 To create the envelope, rule lines over half of the area of the parchment paper envelope. As before, rule up with 7 pen-widths for the top line, and 4½ pen-widths for the x-line.

6 Now use the second nib to create the lowercase letters in ink. Wait three hours for the ink and gouache to dry before erasing any pencil lines and adding the corner decorations, using black ink and a gold marker pen.

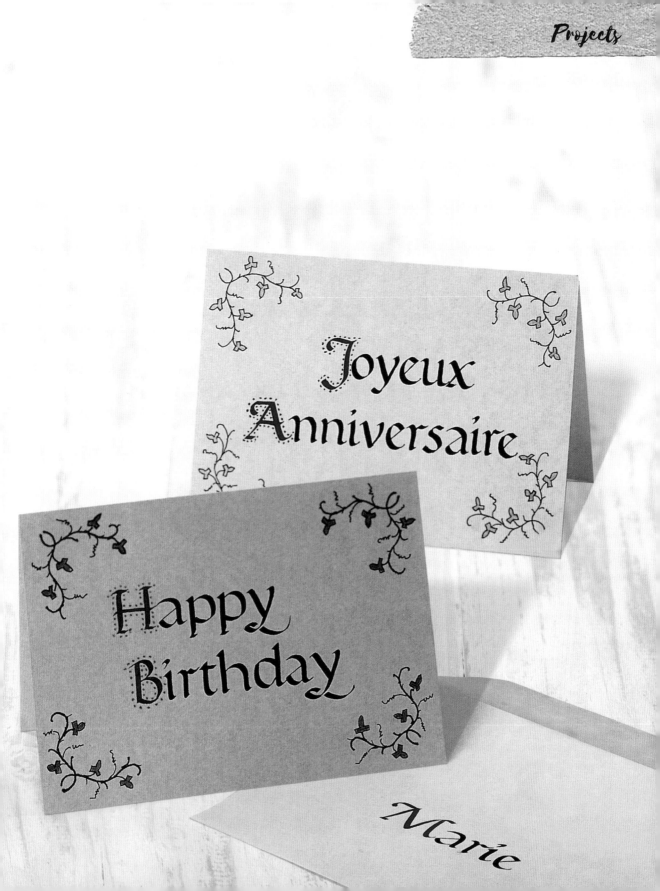

Personal letterhead

Carolingian script has an elegant flowing style that lends itself beautifully to creating a personal letterhead. Before you start think about how you would like your name to appear and the data you wish to include so you can plan the best design.

1 First, rule lines on a sheet of cartridge paper to practice on. Measure 1 in. (2.5 cm) from the top and draw a pencil line across. Dip the nib in the ink, hold it sideways and mark 7 pen-widths down the left side for the capitals (4½ pen-widths up for lowercase). Practice the name, using the larger 30 double-point nib. This is the first line.

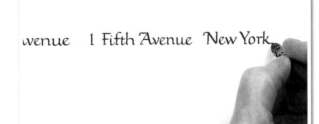

2 For the address, draw two pencil guidelines ¼ in. (6 mm) apart. Go down the paper measuring the pen width of each nib you are going to use. Practice writing out the address you are using, both in capitals and lowercase letters.

Materials

Practice cartridge paper
Good-quality letter (A4) paper
Soft 2B pencil
Eraser
Ruler
Penholder
Speedball size C5 nib
Reservoir
2 double-point nibs:
 sizes 30 and 40
Black fine-line pen
Metallic silver or gold pen
Size 4 paintbrush
Gum Arabic
2 fine paintbrushes:
 sizes 000 and 1

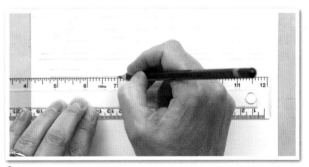

3 On a sheet of good-quality paper measure 1 in. (2.5 cm) down from the top. Draw a line across. Place a ruler across the width of the paper to find the center. Pencil a mark at the top and bottom of the paper. Draw down to mark the center line.

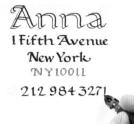

Anna
1 Fifth Avenue
New York
NY 10011
212 984 3271

4 Draw your guidelines
(7 and 4½ pen-widths). Allow
³⁄₁₆ in. (5 mm) between the lines,
and ⁵⁄₁₆ in. (8 mm) between the zip
code line and the telephone number
line. From your practice writing
measure the width of the lines.
Place the ruler along each line to
find the center and mark this on the
layout. Do this for all the lines. Now
write the name and address as you
have practiced.

·**Anna**·
1 Fifth Avenue
New York
NY 10011
☎ 212 984 3271

·**Anna**·
1 Fifth Avenue
New York
NY 10011
☎ 212 984 3271

5 The last line is for your telephone
number. Change the pen nib to the
size C5 steel one. Now write the line
as you have practiced. Allow all the
ink to dry completely before erasing
your pencil lines.

Vacation giftwrap

This cheerful giftwrap will enhance any gift and demonstrates how versatile Carolingian script can be. In this project, bright gouache colors are used as a change from more formal black ink, and the phrases are written at different angles in keeping with your carefree wanderlust spirit!

Materials

Soft 2B pencil
Eraser
12-in. (30-cm) ruler
Several sheets of practice cartridge paper
1 sheet of 11 x 17 in. (28 x 43 cm) cartridge paper
1 sheet of 11 x 17 in. (28 x 43 cm) cream or light-colored paper
Black ink and penholder
Speedball size C2 nib and reservoir
Gum Arabic
5 jars of water
1 palette or saucer
5 size 4 paintbrushes
6 gouache colors:
 – scarlet red
 – ultramarine
 – emerald green
 – corn yellow
 – purple
 – white

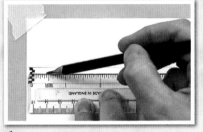

1 Take a sheet of practice cartridge paper and measure out the stave with a ruler. You should allow ⅝ in. (16 mm) for lowercase letters and 1 in. (2.5 cm) for capitals. Draw 3 pencil lines across the paper. Leave a 1½-in. (3.8-cm) space and then mark down the left side of the paper in pencil and rule up the whole sheet.

2 Start by practicing writing the English phrase using ink. Dip the pen into the ink bottle halfway up the nib. Take off the excess ink by stroking the nib on the edge of the bottle. Keep the pen at a 30° angle and write with an even pressure. Practice this several times.

3 Repeat the process, practicing writing the phrases in the other languages.

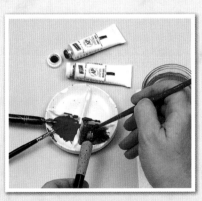

4 To mix the colors use a palette, five jars of water (one for each color), and add a little gouache color. Add a drop of gum Arabic to each color using the end of the brush and mix together with a little water until it is the consistency of light cream.

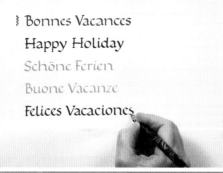

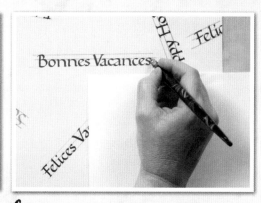

5 Load a nib with color and practice each phrase, again using one color for each language. Wash your nib after each color or the different paints will blend. Load another color on the nib and repeat the process until you have written all the phrases in different colors.

6 Practice marking guidelines on the paper using the same measurements as before, but this time vary the angle of the lines—some can even be upside down. You do not have to measure the width of the lines unless you want to be very precise as it does not matter if your writing goes off the edge of the paper. Write each language phrase in a different color, using the same method as before.

7 Now mark out lines on the final sheet of paper as before and write the phrases in different colors as you've practiced. If the gouache starts to dry out, add a little water to keep it workable. When completely dry, erase the pencil lines.

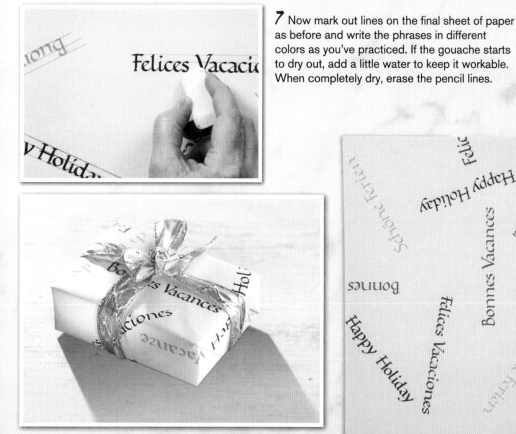

Language of love scroll

This love scroll is a perfect gift for that special someone in your life—and shows you care. Three ribbons complete the scroll—one to hang it, one threaded through as decoration, and one to keep it rolled up before you present it. You can copy the heart here, or draw your own, if you prefer.

Materials

Tracing paper
Pencils: soft (2B), medium (HB), and hard (H)
Eraser
Ruler
Good-quality letter paper
Cartridge paper (for practice)
Red gouache color
Gum Arabic
Palette
Jar of water
Penholder
Speedball size C5 nib
Reservoir
Size 40 double-point nib
Size 4 paintbrush for mixing
Size 00 sable brush
1 yard (1 m) red satin ribbon
PVA glue
Sharp craft knife

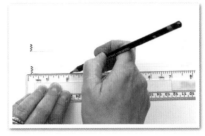

1 Mark the paper with practice lines: 7 pen-widths for capitals; 4½ for lowercase. Mix a little gouache with 1 drop of gum and some water, and, using a size 4 brush, apply it to the size C5 nib.

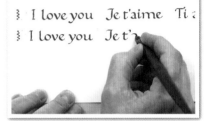

2 Practice the phrases. On scroll paper, draw a box 6 in. (15 cm) by 12 in. (30 cm). This is the outer edge. Inside this draw a second box 1 in. (2.5 cm) in the sides and 3½ in. (9 cm) in from top and bottom lines.

3 Measure ⅜ in. (10 mm) all the way around inside the center box to give you 7 pen-widths for the top line. From this inside pencil line measure outward ¼ in. (6 mm) for the x-line (4½ pen-widths).

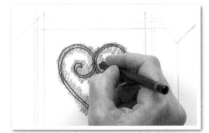

4 Trace the heart using an HB pencil. Turn the tracing over and rub with a soft 2B pencil on its side. Turn the tracing over again, place in the center of the scroll and use an HB pencil to transfer the design to the scroll.

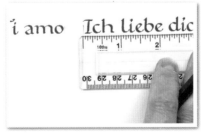

5 Measure all of the phrases you have written on the practice sheet. Now find the center point on the line of each phrase. You will shortly transfer these measurements to the scroll.

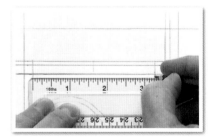

6 Measure the innermost box, halve it to find the center and mark with a soft 2B pencil. Working either side of the center point, transfer the measurements taken from your practice writing and put pencil marks at the start and end of the guideline. Do this on all four sides.

7 Mix your gouache again, adding a drop of water to the mix. Use a size 4 brush and apply the red gouache color to the C5 nib. Now write the first phrase at the top. Wait until the gouache has thoroughly dried before turning the paper around and writing the next line.

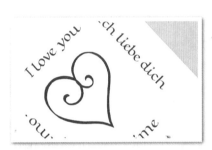

8 Using the red gouache, fill your size 00 brush and paint the red heart using smooth strokes. When it has dried completely, use the double-point nib size 40 to draw the little hearts. Fill the nib using the size 4 brush (no reservoir is used with this nib). You can draw the hearts in different sizes and directions, but keep within the outermost pencil lines.

I love you

Ti amo·

Ich Liebe dich

Je t'aime

9 Cut out the scroll along the outer pencil lines. Measure down 1 in. (2.5 cm) and fold over. Tuck a ribbon under, glue and knot. Measure up 1 in. (2.5 cm) from the bottom and fold. Cut slits in the fold at equal distances, open out, and thread a ribbon through. Now erase the pencil lines. Finally, roll the scroll and tie a ribbon round the middle.

Language of love scroll 55

Party invitation

Get ready for the party season by making these brightly colored, handmade invitation cards to send to all your guests. This fun technique merges different gouache colors for a "neon" effect to the writing and decoration. For this project we have used plain white card, but you can use different-colored card to add a touch of variety.

Materials

White 8½ x 11 in. (21 x 28 in) card
Practice cartridge paper
Soft 2B pencil
Pen holder
2 Speedball nibs: sizes C2 and C5 and reservoirs
Black calligraphy ink
Ruler
Eraser
4 gouache colors: red, blue, yellow, and green
Gum Arabic
4 jars of water
4 size 3 or 4 paintbrushes
Palette

1 On a sheet of practice paper draw a stave (top, x-line and baseline) 2 in. (5 cm) from the top. Keeping the pen at a 30° angle, write the word "PARTY." Practice this a few times until you are happy with it. Wash the nib well after writing.

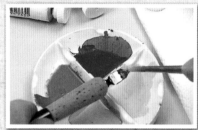

2 Use the brushes to apply gouache to the nib. You will be letting one color merge with another, without washing the nib. Use a different brush when adding colors to the nib, and also separate jars of water for each brush, to keep the colors pure.

3 Now write "PARTY." To start write the "P" in red. Continue in red for the first part of the "A," but before completing it load the nib with yellow. Now start the "R" in yellow then add green. Carry on like this, finishing the "Y" in blue.

4 Fold the card in half widthwise and cut along the fold. Take one of the pieces and draw a wavy line decoration down the right edge. It is a good idea to practice on cartridge paper first. Use a brush to load the nib with blue gouache to start. As you draw your line, switch colors—just as you did before—this time changing to green and then yellow, and finishing with red.

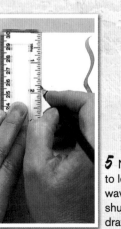

5 Now fold the card lengthwise ⅜ in. (10 mm) off-center to leave a narrow strip down the right side so that the wavy line you've drawn is visible when the card is folded shut. On the front of the card, find the middle point and draw a line straight down.

6 Now draw straight lines for the letters. Measure 1½ in. (3.8 cm) down and draw a short line, repeating all the way down your card, using a measurement of ¾ in. (20 mm) for each letter and a ⅜ in. (10 mm) space between letters.

7 Start with the red gouache, just as you did before, and load your nib using the brush. Write the letters, changing the colors just as you have practiced. When the gouache is completely dry, erase your pencil lines.

8 Finally, use a size C5 nib to write "FIESTA" across the top and bottom of the card.

FIESTA FIESTA

P
A
R
T
Y

FIESTA FIESTA

CHAPTER 2: *ROMAN CAPITALS*

From the first century B.C.E. to the present day, Roman Capitals have been used in many forms. The form is derived from the Greek alphabet (via Etruscan) and achieved its status through the work of Roman master stonemasons, who carved it on great stone columns.

Also known as Roman majuscule letters, Roman Capitals were in use throughout the Roman Empire, carved on many of the buildings of this period. The best known example of this script is on the carved stone column of Trajan, which is covered in wondrous figures and Roman Capitals carved in deep relief by master stonecutters.

Roman Capitals passed out of use at the beginning of the medieval period, and did not reappear until the end of the 15th century, when they were revived by the Humanists.

As the name suggests, this script uses only capital letters, comprising straight, precise angles and sweeping curves.

The vertical lines narrow slightly in the center and curve outward at the top and bottom. They have great definition between the thin and thick lines. Spacing and the proportion of the letter are also important.

Roman Capitals are sometimes called Versals, the name originating from the use of the script in the manuscripts of Biblical verses. Each verse began with a large "illuminated" (decorated) letter, called a Versal. Some manuscripts used Roman Capitals in skeletal form, leaving the letters hollow by drawing them with a quill pen. Modern techniques use this method too, but with a steel-point or oblique steel nib.

CAPITAL ALPHABET

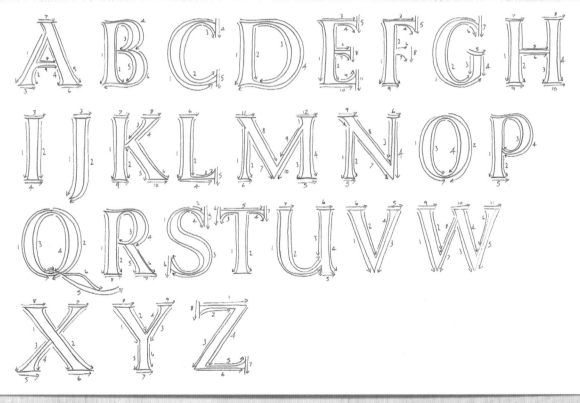

Use the stroke sequence arrows to complete the alphabet.

HOW TO DRAW THE LETTER "A"

1 Draw the farthest edge first, including a small sweep at the bottom for the serif.

2 The inner side of the stroke is parallel until it nears the bottom, when it curves inward. Do not worry about leaving a gap for the crossbar at this stage.

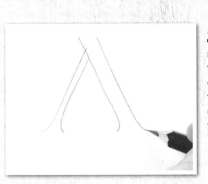

3 The right-hand stroke is wider than the left. Start each side at the top line and open out the serif at the bottom.

4 Enclose the feet and the top of the letter before adding the crossbar a little under halfway up the letter.

HOW TO DRAW THE LETTER "R"

1 Start with the letter's vertical section. To ensure that the sides are not exactly straight, give each edge a gentle concave curve.

2 Draw the outer bowl first in a single movement before inserting a tighter curve inside.

3 Add the foot, finishing to the right of the bowl. Let the foot widen at the base and add an extra curve to the right-hand side.

4 Finish the letter by enclosing the feet with horizontal lines along the baseline.

HOW TO DRAW AND PAINT THE LETTER "V"

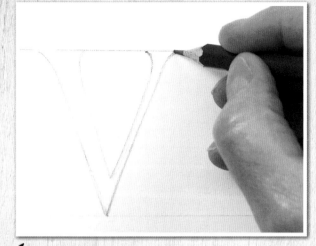

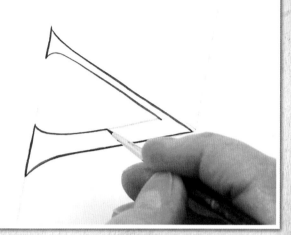

1 First take a piece of good-quality white cartridge paper. With a 2B pencil, draw a top line and baseline 2 in. (5 cm) apart. The letter "V" is made up of six strokes. Take care to keep the pencil lines light. Start at the top left and draw a curve to form the serif, then draw a line diagonally to the right and stop at the baseline.

Go back to the top left. Start at the top line again and curve the other side of the serif and then draw a line parallel to the first one, as shown. Stop before the baseline. Now go up to the right side and, using the same technique, draw a line diagonally down to the left to meet the first line you drew, forming the "V."

Now up to the top right and draw another line, not so far apart, to meet the second line you drew. Finally, draw the two horizontal lines at the top to complete the letter.

2 Mix some purple gouache with a little zinc white in a palette. With a size 4 brush, add water and a drop of gum Arabic and mix to the consistency of light cream. For outlining, the gouache needs to be a little more watery. Put a little of the mixture to one side and add a little more water. Use a size 0 brush and paint over your pencil line with a thin brush line. Keep an even flow with the brush.

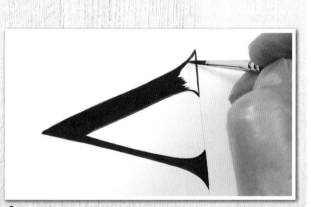

3 Take a size 1 brush and, using the rest of the gouache mix, start to fill in the body of the letter. Start at the top and follow through as quickly as possible until you have painted the whole letter.

SIGN WRITING

Often a Roman Capital alphabet is used for modern sign boards because the letters are easily read from a distance, while still looking classical and timeless. For sign writing, a special enamel paint is used that gives a good opacity. Special long, flat, chisel-shaped brushes are needed for this type of lettering.

INCISING

Incising letters means cutting in stone or wood using chisels (see pages 68–69). Roman Capitals are commonly used today as they were in the first century C.E. They can be cut into the stone with special steel chisels and a small-headed hammer. Slate, marble, and stone are fine surfaces for stone carving. Granite can be used but is a very hard stone to carve. You can cut into wooden surfaces in the same way, using wood chisels and a wooden mallet. Lime wood is especially good for wood carving.

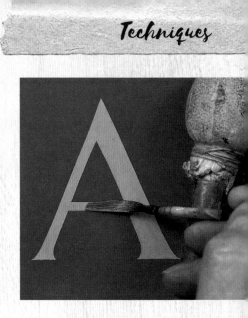

Common mistakes, tips, and problem solving

There should be definition between the thick and thin lines. A common mistake is to make the straight lines too thick and the curved lines too thin. A tip when drawing out the letters in pencil is to use a soft pencil and apply even pressure and a light touch. Then, if you make a mistake, it is easier to rub out the lines and re-draw them. If you press too hard with the pencil the score marks they leave will still show on the paper.

Keep the letters in proportion, with small serifs, taking care not to exaggerate lines.

Serifs should not be too wide, but balanced with the straight lines.

The straight lines should show clear definition between thick and thin strokes.

Be confident when writing and don't allow wobbly lines.

Take care to keep the letter within the stave.

Coming-of-age card with Latin motto

In ancient times, Roman Capitals were carved onto milestones marking the distance to the next town. So what better script to use for a card marking important milestones such as coming of age! The border is a typical Roman wave design used on mosaic floors in the first century C.E.

Materials

Tracing paper
Practice cartridge paper
Cream card
2 pencils: soft (2B) and hard (H)
Eraser
Ruler
Masking tape
2 gouache colors: light blue and ultramarine blue
Palette
Jar of water
Penholder
Speedball size C6 nib
Ink reservoir
2 paintbrushes: sizes 00 and 1
Fine-line black pen

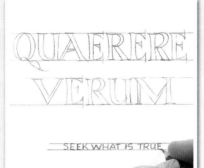

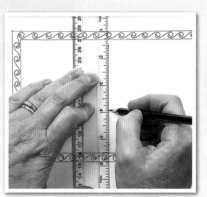

1 Start by practicing the Latin quotation in Roman Capitals on a spare sheet of white cartridge paper. Draw guidelines 5/8 in. (16 mm) wide with a gap between of 3/8 in. (10 mm). Measure down 7/8 in. (22 mm) and draw another set of lines 1/8 in. (3 mm) wide. As you write keep even spacing between letters and ensure there is a contrast between the thick and thin lines.

2 Take a sheet of tracing paper and fold it in half. Trace the border design and add a vertical line down the center.

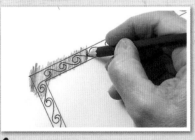

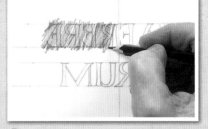

3 Turn the tracing paper over when you have drawn the design and rub a soft 2B pencil over it to carbonize.

4 Attach the corners with masking tape and trace the letters, using the center line to ensure it is centered for each line of lettering.

5 Turn the tracing paper over and carbonize the back of the lettering.

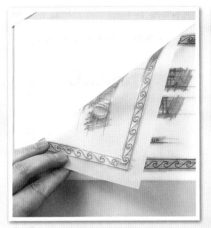

6 Now place the design onto your card. Stick it down and go over the border and lettering with a hard H pencil to transfer the design and script. Do not press too hard. Make sure you also draw the pencil lines for the writing.

7 Using the size 4 brush, mix light blue gouache paint with water and a drop of gum Arabic until it is the consistency of watercolor paint. Now take a size 1 brush and paint the wave design. Once you have painted all the waves, mix the ultramarine blue and fill in the space around the waves, as shown above.

8 Use the light blue gouache and a size 1 brush to paint the text. When complete use the C6 nib and the darker ultramarine blue to write the English translation in simple capital letter script. When the paint is dry, gently rub out the pencil lines. To finish outline the wave border with a fine-line black pen.

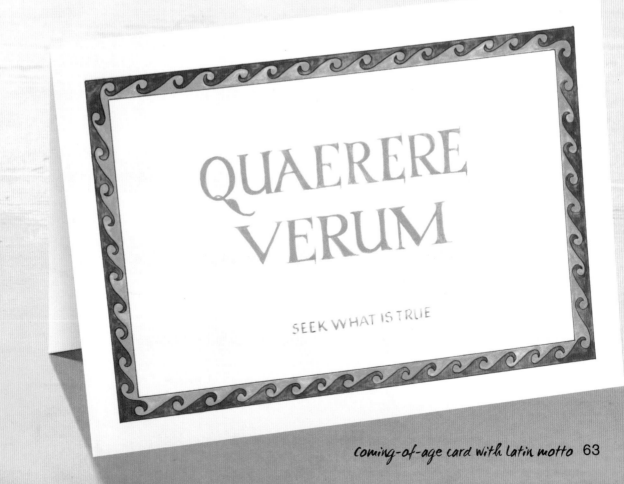

Petrarch plaque

In Roman times, the homes of the wealthy often had mosaic floors made up of small, square blocks known as tesserae—often featuring a rope border. This plaque is based on a typical Roman mosaic and features a verse by the poet Petrarch, taken from his poem *Canzoniere*.

Materials

Cream or white practice paper
2 pencils: soft (2B) and hard (H)
Penholder
Speedball size C3 nib
Fine-point nib
Reservoir
Fine-line black pen
Long ruler
3 waterproof inks: dark orange, gold, and dark brown
Size 1 paintbrush
Sheet of 11 x 17 in. (28 x 43 cm) light buff-colored paper
11 x 17 in. (28 x 43 cm) tracing paper
Eraser
Masking tape

Quelle pietose rime in ch'io m'accorsi
Di vostro ingegno et del cortese affecto,
Ebben tanto vigor nel mio conspetto
Che ratto a questa penna la man porsi

1 Draw a group of three-line staves on a practice sheet and practice writing out the words using a size C3 nib, drawing the first letter of each line from the Roman Capital alphabet. The bottom line of writing is small Roman Capitals with a fine-point nib. Measure your lines of writing so that you can position them on the final sheet.

2 Use a long ruler to draw out the area for the border on an 11 x 17 in. (23 x 48 cm) piece of tracing paper. Now position the tracing paper over the rope design so that it fits within the border and trace.

3 Rule lines on the 11 x 17 in. (23 x 48 cm) buff-colored paper, including a center line. Draw the Roman Capital in pencil at the beginning of each line, then use a fine-point nib to cover it in dark brown ink before writing the rest of the lettering in lowercase Carolingian script in dark brown waterproof ink.

4 When it is dry, fill in the letter using gold ink. You have to keep stirring the ink before you use it or it will separate.

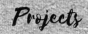

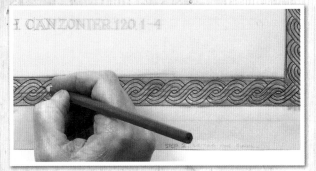

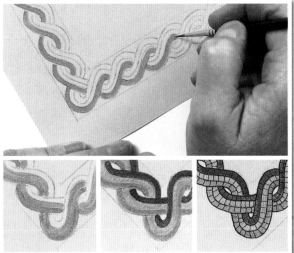

5 Turn over your rope border tracing and rub it with a soft (2B) pencil to carbonize. Turn it over again and use a hard pencil with a sharp point to draw over the tracing. Now fill between the lines with each color ink (shown right and far right) —first light orange, then gold (keep stirring), and finally dark brown. Take the ink straight from the bottle, using a size 1 brush and paint each band carefully. Make sure each color is dry before starting the next or the colors may bleed into each other.

6 Finish by outlining the rope bands with a fine-line black pen and add little lines across each band (shown right) to simulate the tessera squares of Roman mosaic.

Quelle pietose rime in ch'io m'accorsi
Di vostro ingegno et del cortese affecto,
Ebben tanto vigor nel mio conspetto
Che ratto a questa penna la man porsi.

PETRARCH CANZONIER 120. 1–4

Translation

These kind verses in which you show me
your wit and your courteous affection,
show such concern, to my mind,
that I am forced to reach for my pen.

Latin love scroll

This Latin inscription makes an enchanting love token to give to a close friend or partner. The paint is mixed to a watercolor consistency to give a light, airy effect and the Roman Capitals are written in outline to allow the design only to show through for a delicate touch to the scroll.

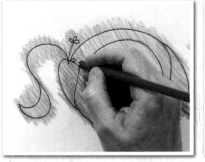

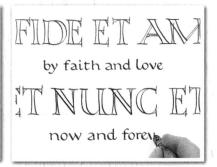

1 Use the template to enlarge the heart design to fit onto an 8½ x 11 in. (21 x 23 cm) sheet of paper. Trace this onto tracing paper before turning it over and carbonizing the design with a soft 2B pencil. Place the sheet on top of the parchment card, stick it down, and transfer the design to the card with a hard H pencil.

2 Mix the gouache colors with water and gum Arabic in a sectional palette until they are the consistency of watercolor paint—they need to look light and translucent on the card. Paint the design with each color in turn, starting with the yellow, then the green, and finishing with the red.

3 On the practice card measure ¾ in. (20 mm) for the Roman Capitals and ¼ in. (6 mm) for the English translation. Leave a space of ⅝ in. (16 mm) between the writing. Practice the Latin lettering in pencil, then go over the letters with either a pointed nib or a fine-line black pen. Now practice the lowercase writing.

Materials

- 2 pencils: soft (2B) and hard (H)
- Eraser
- Ruler
- Masking tape
- Penholder
- Speedball size C6 nib
- Reservoir
- Fine-line pen or fine-point nib
- 2 paintbrushes: sizes 1 and 4
- 3 gouache colors: yellow, green, and dark red
- Gum Arabic
- Palette
- Jar of water
- 8½ x 11 in. (21 x 23 cm) sheet of parchment-colored card
- Tracing paper
- White card or cartridge paper

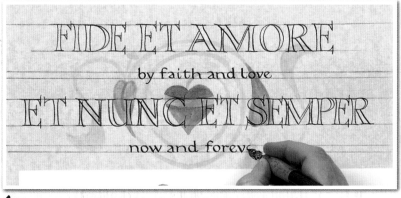

4 Find the center of the parchment card and draw a vertical line with a soft 2B pencil. Measure the length of your practice writing and put pencil marks at the beginning and end of each line, centered around the vertical line. Draw the Roman Capitals softly in pencil. Now you can use a fine-line pen or a pointed nib and pen them in black over the pencil lines. The letters are left open so you can still see the design.

5 Finish by writing the lowercase letters of the translation below the Roman Capitals using a dark red gouache. Gently rub out the pencil lines and roll up the scroll, tying it with a red ribbon.

Relief carving on wood

The angular Roman Capital script lends itself to relief carving on wood. Use a craft knife to score the outline and then a chisel to carve. By cutting wood away at an angle you can create a pleasing effect around each letter. You can take out all the wood around the letters if you wish, but this takes a little longer.

Materials

Block of lime wood
Fine-grain sandpaper
Medium HB pencil
Eraser
Ruler
Sharp craft knife
Carving chisels:
 straight, beveled,
 and V-shaped
Vice
Wood plane
Gloves

1 Take your piece of wood and lightly sand it with fine sandpaper. Wipe off the dust.

2 Now use your ruler and pencil to draw lines top and bottom on the wood. Draw your letter or number.

3 Protect your hands with gloves and use a vice to hold the wood in place, otherwise the knife or chisel may slip and cause injury. Start by using the straight chisel or craft knife, keeping it in an upright position, to go down the straight sides and top of the letter pressing into the wood to score a line.

4 The serif can be cut into the wood with a rounded beveled chisel. If you have only straight knives or chisels use the thinnest and go around the curve using small cuts.

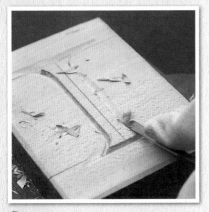

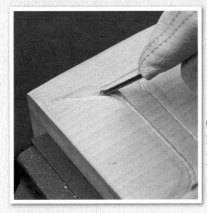

6 Use a fine chisel to finish. When you have chiseled all the wood from around the letter, the carving is finished. You can take the edge off the block of wood with a small plane, if you have one.

5 Remove the wood from the sides of the letter using a straight chisel at a flat angle. This makes the letter "pop" out of the wood. Do not rush—once wood has been cut mistakes are not easily corrected.

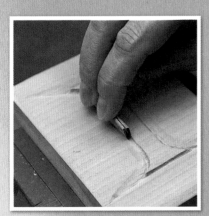

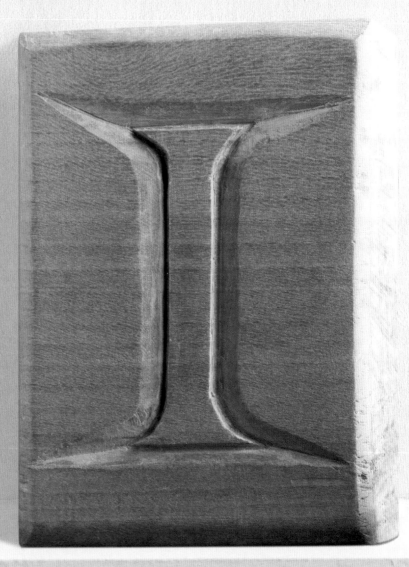

7 Give the letter a quick sanding using the fine-grain sandpaper and it is finished.

Stenciled t-shirt

Roman Capitals are not just used for mosaic patterns and carving wood—
their clear lines are ideal for stenciled designs on t-shirts and sweatshirts,
too. In this project a large, bold "X" is used for maximum effect, but you could
also stencil your initials or the name of your favorite celebrity or sports team,
using the alphabet on page 58.

using the alphabet on page 58.

Materials

White cotton T-shirt
Stencil card
Craft knife
Cutting board
Steel ruler
Medium HB pencil
Fabric paint
Saucer
Stencil brush
Double-sided tape
Sheet of card

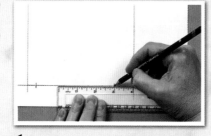

1 Take a sheet of stencil card.
Draw the top and baselines and
then vertical lines to make a box.
Add marks to show the width of the
diagonals—1 in. (2.5 cm) for the wide
diagonal, 1½ in. (3.8 cm) for the
narrow. By making the numeral as
large as this it is easier to cut out.

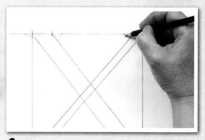

2 Draw your letter "X" with a medium
pencil, joining the marks previously
made. Add in the serifs by hand—
these do not have to fit inside the box.

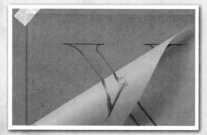

3 Transfer the letter onto a sheet of
tracing paper before carbonizing the
reverse and transferring it onto
a sheet of waxed stencil card.

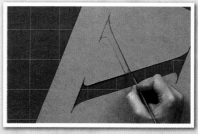

4 Place the stencil card on a cutting
mat held in place with masking tape.
With even pressure, cut out the
stencil, keeping the blade at an angle
to the card. Always cut well away
from your hands.

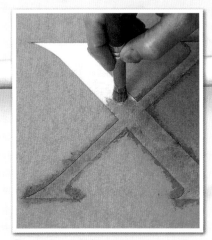

5 Lay a clean, uncreased T-shirt on a flat surface with a sheet of thick card inside. Use double-sided tape stuck on the underside of the stencil card to hold it in position. (Place the tape near the points of the letter to ensure they do not lift during stenciling.)

Use a short bristle stencil brush to work the paint into the fabric, going over the edge of the stencil card to get a good line at the edge. Go all over the fabric that you are filling in. Keep loading the brush, as the fabric quickly soaks up a lot of paint.

6 Wait for the paint to dry before carefully removing the stencil. After a few hours, iron the T-shirt. Always put a clean piece of fabric between the iron and the T-shirt. This will "fix" the paint so it can be laundered without the paint being washed out.

CHAPTER 3: *UNCIAL & HALF-UNCIAL*

Uncial scripts developed along with the growing use of animal skins
for manuscripts. Unlike Roman Capitals, Uncial scripts are written
with the pen in one position and so used by scribes of the
British Isles to copy works of the early Christian church.

During the first millennium C.E. the monasteries of the British Isles were places of great learning, especially in Celtic countries such as Ireland and Scotland, and on tiny Lindisfarne Island (also called Holy Island), off the coast of Northumbria, in north-east England.

From the first to the fourth centuries C.E., books developed into a form we would recognize today, gradually replacing scrolls as the principal way of presenting text. With the book came new scripts, now known as the "Uncial family," which included Half-uncial and Insular.

The most famous books of the period included The Book of Kells, written on the small island of Iona off the west coast of Scotland, The Book of Durrow, written in Ireland, and The Lindisfarne Gospels, written on Holy Island.

Books were written in a special room called a Scriptorium and took many years to complete. Some were produced by a single scribe using a quill pen held at a flat angle to the paper, giving these scripts their characteristic appearance. The quill was cut from the flight feathers of a large bird, such as a swan, goose, or crow.

The Uncial family of scripts are rounded in formation. There are both "majuscule" (capitals) and "minuscule" (lowercase) variants, and manuscripts were produced in one or the other form. Initial letters would be "illuminated," that is written much larger than the text and embellished, perhaps with elaborate interlacing Celtic knots, or animal forms known as zoomorphics.

The Celtic scribes of the seventh and eighth centuries, in particular, were masters of art, design, and calligraphy. Sometimes they produced pages featuring Celtic designs only—and no text at all. These are known as carpet pages and were masterpieces of the scribe's art.

CAPITAL ALPHABET

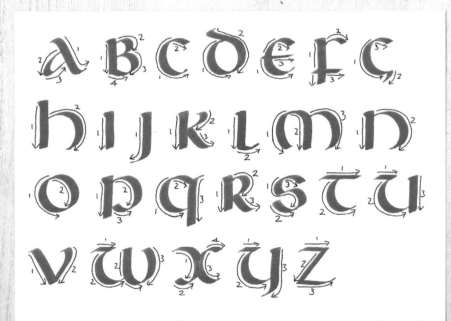

Use the stroke sequence arrows to complete the alphabet.

CREATING THE LETTER STAVE

1 Start by drawing a pencil line across the paper for the x-line. Then mark 4 pen-widths down the left side, holding your nib at a right angle to the paper, followed by half a pen-width, to give the correct spacing.

2 From the bottom pen mark draw another line across the page. This is the baseline; the space in between is the x-height of the letters. You can write Celtic scripts between 4 and 5 pen-widths—as you prefer. Now repeat the process to fill the whole page with staves.

HOW TO DRAW THE LETTER "H"

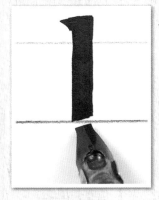

1 Hold the nib at a flat angle to the guideline to give the letters their rounded appearance and draw the pen down. Add a short stroke at the top, as shown here, for the serif.

2 Keep the same angle to achieve the crescent shape of the letter's bowl.

HOW TO DRAW THE LETTER "F"

1 For "f," repeat the first stroke of the "h" but take it past the baseline to create a descender.

2 Add the top bar of the letter with a shortened curve that rises to touch the top line of the stave.

3 Draw the center crossbar along the baseline and give it a little flick downward to finish.

THE HALF-UNCIAL SCRIPT

In the Irish Half-uncial alphabet, the letters "B," "D," "H," "K," and "L" rise above the top line, and "F," "G," "J," "N," "P," "Q," and "Y" fall below. Some Half-uncial letters, such as "B" and "L," have ascenders resembling fishtails. The script is rounded and the letters are quite thick. This script is easy to read and pleasing to the eye.

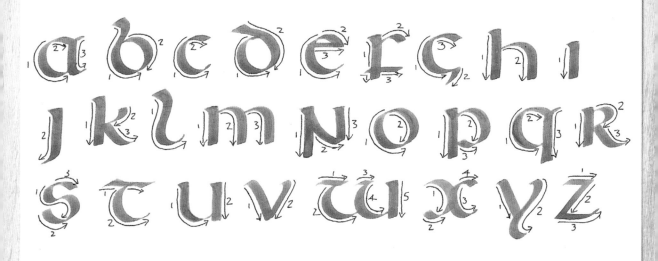

WRITING THE LETTER "D"

1 With the pen at a flattened angle, as in the Uncial script, make a reverse crescent.

2 Exaggerate the top of the tail and bring it around to meet the bottom of the crescent.

WRITING THE LETTER "N"

1 The left-hand side of the "n" drops below the baseline as a descender.

2 Turn the diagonal stroke into an upward sweep.

3 Bring the right-hand side of the letter down. Finish above the line to show the pen angle.

1 Draw the body of the letter in a single stroke, keeping clear definition in the left-hand sweep.

2 Enclose the bowl, starting close enough to the x-line to reach it while still on the upward movement.

3 Add weight to the "fishtail" by giving definition to the letter's ascender.

PEN NUMERALS

Writing Half-uncial numerals in pen involves exactly the same techniques as writing the alphabet itself. Keep the pen at the same flattened angle throughout and follow the stroke sequences shown to build up each number.

As with other Roman scripts, Half-uncial numbers are slightly less ornate than the letters. Nevertheless, they still retain the same pleasing sweeping and rounded form of the letters.

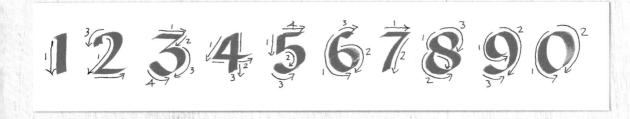

Common Mistakes, tips, and problem solving

The following are some of the commonest mistakes when constructing the Uncial and Half-uncial scripts:

- Not marking the height of the guidelines accurately. Take your time and try to keep the square-cut nib on the paper when marking the side of your paper in ink.
- Filling the nib too full with ink when loading. This causes the letters to be thick and blobby. Once you have dipped the nib into the ink, take off the excess ink by stroking it on the side of the bottle neck.

- Not holding the nib flat to the paper at all times. This is a very common mistake. You need to keep the nib at 45° or so. But to form the letter well, practice your writing while holding the nib flat to the baseline and let the letters flow.
- Wrong stroke sequence. Follow the alphabet arrow sequence shown. This will help with the stroke directions and how to build the letter correctly, especially with the letters "M," "S," "W," and "X."

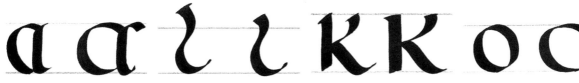

Make the curves of the letters rounded, and never let them be too narrow.

Never raise an ascender more than 1–1½ pen-widths above the x-line.

Keep the nib flat as this gives a much nicer shape.

To form the letter well, practice holding the nib flat to the baseline and do this every time.

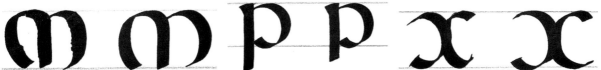

Never overload the nib with ink, which makes the letters thick and blobby.

Avoid dropping too far below the baseline. The nib should be 1–1½ pen-widths below a line.

Keep the letters in proportion and avoid making them squashed or overextended.

Illuminated letters

The Celtic scribe used illuminated letters at the beginning of a sentence, or beginning a Gospel page, or to show the importance of a name. Illumination means to "light up" and this is sometimes achieved with color, Celtic designs, or with simple decoration.

The simplest illuminations were written in black ink bigger than the normal line of writing. The scribes also added color to the inside of the letter using a simple dot design. By adding simple black or red dots around the outside of a letter, a process known as "rubrication," the scribes made the initial stand out. Some letters had a simple knotwork design added to the inside or the top of a letter, making the letter appear larger. Another form of illumination was to use spirals, key patterns, and animal designs. Some of the animals were recognizable, while others were intended as comical hybrids or were taken from mythology.

Animal heads were often drawn at the beginning of the interlacing knotwork, sometimes depicted with their mouths open and their teeth or tongue holding on to the interlacing Celtic band. The animal's feet or a tail would then be drawn at the end of the knot.

Some letters filled the whole page with color and were so intertwined with Celtic art that it is sometimes difficult to see exactly where the letter begins and ends.

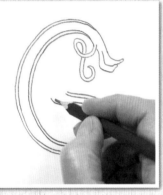

1 Trace or draw the letters onto tracing paper. Turn the tracing paper over and rub over a soft 2B pencil to carbonize it.

2 Turn the tracing over again and go over the letters using an H pencil to transfer the design to the sheet of parchment paper.

3 Paint the letter and decoration with bright gouache colors using a fine brush. Ensure you allow each color to dry completely before adding the next one. Outline the design using a fine-point black pen.

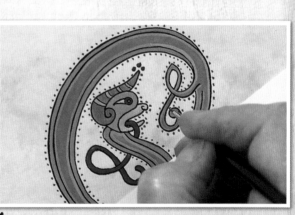

4 Finally, add the rubrication (red dots) around the letters. This technique is used for all illuminated letters and motifs. Why not design your own letters? Look at the motifs opposite for inspiration.

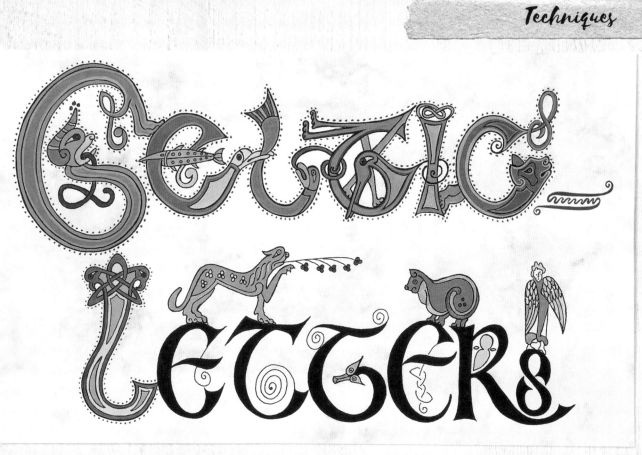

Flourishes can be geometric or zoomorphic. They can be part of the letters or additional decorations.

You can use these designs and zoomorphic motifs as decorations for your own illuminated letters, or some of the other designs on pages 122–126.

Celtic name plaque

This name plaque in Half-uncial script is a stylish addition to any child's bedroom and is suitable for all ages. The rich illumination features authentic designs from the best Celtic tradition. The templates on pages 122–126 offer a choice of flower, bird, and animal designs, along with a series of classic knot repeats.

Materials

Cartridge paper
5 gouache colors: blue, yellow, red, orange, and green
Gum Arabic
Speedball size C1 nib
Penholder
Size 4 paintbrush for mixing
2 paintbrushes for painting: sizes 1 and 0
2 pencils: soft (2B) and hard (H)
Eraser
Palette or saucer
Jar of water
Tracing paper
Ruler
Fine-line black pen
Masking tape
Ivory mountboard or thick cream card cut to 9 x 4 in. (23 x 10 cm) to give firm backing

1 For the girl's plaque, choose a border from the templates. Use the 2B pencil to trace it onto the tracing paper. Add repeats to fit. Turn over the tracing paper and rub the back with the 2B pencil to carbonize it.

2 Lay the tracing over your sheet of practice paper and stick it down flat using masking tape on all four corners. Use the harder H pencil to trace over the Celtic border around the paper.

3 Rule guidelines across the center of the letter paper with a soft 2B pencil: use 5 pen-widths above and below. See page 74 for the alphabet and practice the calligraphy of the name in H pencil.

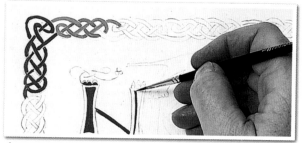

4 Mix the gouache in both red and green. Load the size 1 brush with red gouache and practice the border; rinse, and repeat in green until you are happy with both. Load the size 0 brush with red, and practice the initial.

5 Trace the fox and place it above the calligraphy with its feet on the top writing line. Mix some orange gouache with gum Arabic and water, and use a size 1 brush to paint in the color.

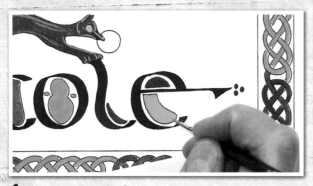

6 Fill in the geometric shapes with blocks of gouache color.

7 Transfer the design to the final sheet and color the border. When dry, use a black fine-point pen to draw around the color work. Put black dots around your initial letter and erase the pencil lines. Finally stick the corners of the project firmly to the mountboard or thick card with masking tape.

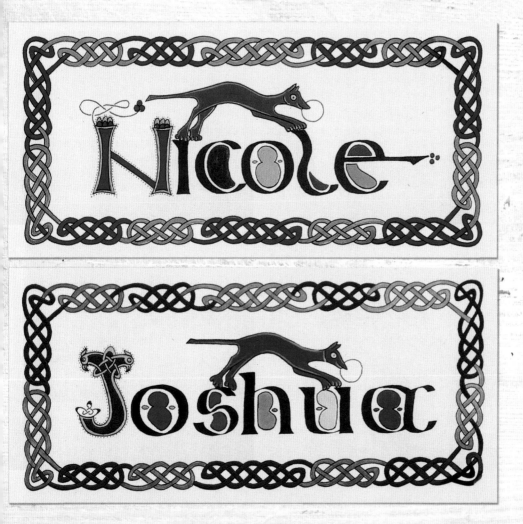

Illuminated letter on vellum

This project features authentic materials that Celtic scribes used to create elegant Bibles and other works. Vellum, which was used in Europe before paper, is calfskin that has been specially treated. The pigment colors came from plants and minerals and were mixed with egg, which acted as a binding agent.

Materials

Cream card
Tracing paper
Vellum or vellum paper 6 x 8 in.
 (15 x 20 cm)
2 pencils: soft (2B) and hard (H)
Fine-line black pen
Fine-line red pen
Eraser
Masking tape
2 gouache colors: red and green
Gum Arabic
2 paintbrushes for painting:
 sizes 00 and 1
2 size 3 paintbrushes for mixing
2 jars of water
Palette for mixing
Egg
2 glass containers
Powder pigment colors: red,
 green, and white
Distilled or mineral water
Fine pounce powder
Very fine sandpaper

1 Trace the template on page 125. Turn the tracing over and use a 2B pencil to carbonize the reverse of the design. Place it onto the cream card and use the hard pencil to transfer the tracing to the card.

2 Mix red and green gouache colors together in your palette, adding a drop of gum Arabic and water, and then paint the colors as shown. This color rough shows how the colors will look on the final form.

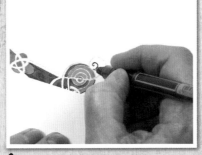

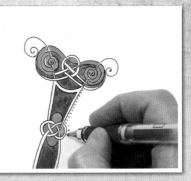

3 Draw in the lines surrounding the colored sections with the black pen.

4 Add red dots around the letter using with a fine-line red pen.

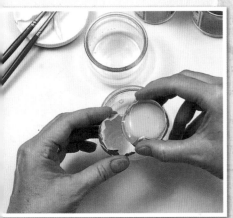

5 With two glass containers on hand, crack open an egg. Separate the white from the yolk, keeping the yolk in one half of the eggshell. Now take the yolk in the palm of your hand and wash it very carefully under the tap, without breaking the yolk sac. Take hold of the yolk sac at the top, hold it over the other glass container and break the sac at the bottom to let the yolk drain into the container. Try not to let any of the egg sac fall into the container.

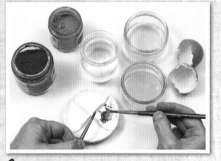

6 Use egg yolk for warm colors and the white for cool colors. Put about a quarter of a teaspoon of red powder in the palette. Now add a few drops of the egg yolk and some mineral water. Mix with the size 3 brush to a creamy consistency.

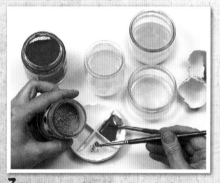

7 Now use another brush to do the same with the green pigment, mixing it with a few drops of the egg white. Try the color on a piece of spare paper first before painting the vellum. If it looks a bit watery, mix more pigment until it looks opaque.

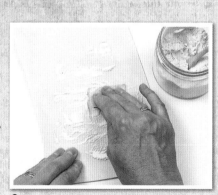

8 If using real vellum take any grease off with powdered pounce. Put a little on the surface and use fine sandpaper to rub over the whole surface in a circular motion.

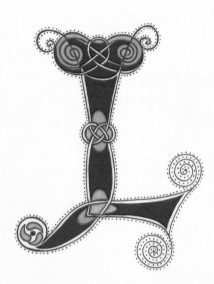

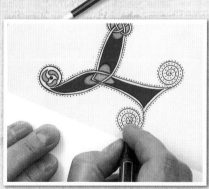

9 Transfer the letter "L" to the middle of the vellum as before, making sure that your hands are grease-free. Start by painting the red color with a size 0 brush. Paint the outer line of the letter first and then, using the size 1 brush, fill in the color. Do the same with the green. When it is dry, mix a little white with some of the green pigment to paint the lighter parts. When the paint is dry go around the letter with a black fine-line pen. Finally, add the black dots around the spiral.

Gaelic prayer

It was traditional in Irish homes to hang up a Gaelic prayer so as to keep the family who lived there from harm. The prayer was surrounded by an elegant border and decorated with animals that had spiritual and symbolic significance. You can copy the templates on pages 122–126 or choose your own.

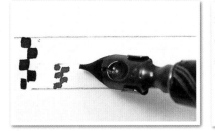

1 Using a soft 2B pencil, prepare a sheet of letter paper with a stave combining two nib widths: 4½ nib-widths with a size C3 nib and 4½ nib-widths with a size C5 nib. This will give you three horizontal lines for each line of writing.

2 Write out the text using the size C3 nib for the initial letter of each sentence and the smaller size C5 nib for the rest of the text. Continue this throughout the text.

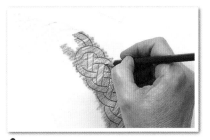

3 Trace part of the border from the photo opposite. Using a large compass draw two concentric circles: the diameter of the outer circle is 11¼ in. (28.5 cm). Carbonize the reverse of the tracing paper and repeatedly transfer the design to make the circle pattern.

Materials

Large sheet of tracing paper
11 x 17 in. (28 x 43 cm)
 cartridge paper
Large sheet of cream card
2 pencils: soft (2B) and hard (H)
Eraser
Long ruler
Large compass
Scissors
Paper glue or masking tape
Various gouache colors
Gum Arabic
Palette
Jar of water
2 paintbrushes: sizes 00 and 1
Fine-line black pen
Penholder
2 Speedball nibs: sizes C3 and C5
2 ink reservoirs
Black ink

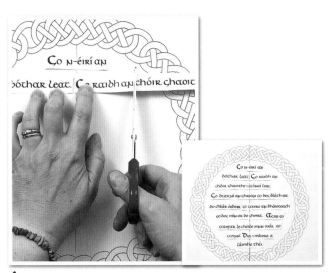

4 Cut out each line from the practice sheet using scissors. Find the center of the practice paper and draw a line down the middle of your paper. Place each line you have cut out on the paper and stick them down with glue or tape allowing even spaces between the lines of calligraphy to give you the layout for the final writing. If any line is longer than the available space cut the line at an appropriate place and take it over to the beginning of the next line.

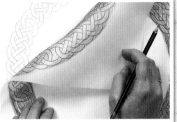

5 Trace the entire border onto a large sheet of tracing paper and carbonize the back. Trace it first onto a sheet of practice paper and then onto 11 x 17 in. (28 x 43 cm) cartridge paper.

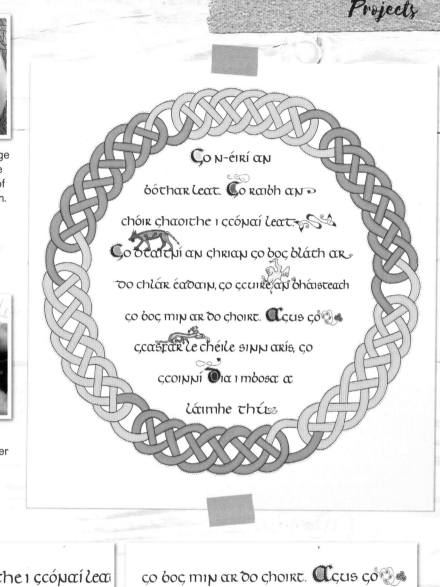

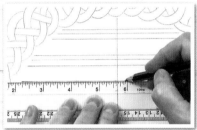

6 Now rule up the cream card. Measure each line in turn and transfer the measurement to the card. Put a pencil mark at the start and end of each line.

7 To write on the cream card, take the larger (size C3) nib for the first letter of the sentence. You will be starting this letter at the top line. Then take the size C5 nib and write the remainder of the line. Follow this method throughout the text. You can add decoration to the larger letters and zoomorphic decorations to the text.

8 Use the size 00 brush and gouache to paint the outline of the knot border. Fill in the rest of the color with a size 1 brush. When dry, add the darker color as an outline on the knot work. When this is dry, outline the border with a black fine-line pen. Add red or black dots to the inside and outside of the knotwork. Erase the pencil marks.

Wooden box

A wooden box decorated with Celtic motifs and initials can make an original gift or a useful container for trinkets for yourself. Adding a coat of varnish before you decorate the box, and covering with a second coat at the end, ensures your work is protected from bumps and scratches.

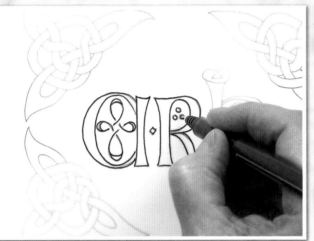

1 Carefully sand the box smooth with fine sandpaper. Wipe off the dust with a damp cloth. When dry, varnish the box and leave it to dry overnight. Turn the box upside down onto a sheet of tracing paper and draw around the lid to mark the boundaries for your design. Write your initials in the center. Copy the Celtic corner motif from the Template section (page 126) and draw it into each corner of the traced area. Then carbonize the back of the tracing paper with a soft 2B pencil.

Materials

Wooden box
Fine sandpaper
½ in. (13 mm) soft brush
Satin varnish
Black fine-line pen
2 pencils: soft (2B)
 and hard (H)
Eraser
Ruler
Tracing paper

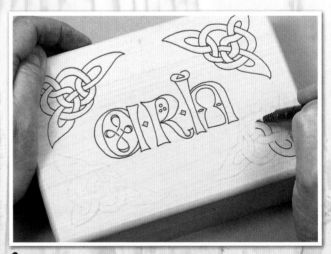

2 Use a hard pencil to trace the design onto the lid of the box. Go over your pencil lines carefully with the black pen until you have covered the design.

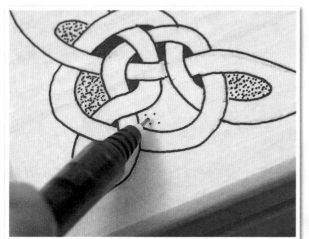

3 Add the dots with the tip of the same pen to finish the pattern.

4 When the ink is dry, rub out any pencil marks left visible on the lid. Finally, varnish the box as before to seal the design in place.

Celtic animal on stone

Decorating a smooth stone you have found on a beach to make a doorstop or a paperweight allows you to add ancient pattern to an object that has existed for many thousands of years. Ancient people may have handled the stone and you can remember them by painting a beautiful design on to it that they would have recognized.

Materials

Black fine-line pen
Tracing paper
2 pencils: soft (2B)
 and hard (H)
Large, smooth stone
Varnish
Carbon paper
Masking tape
Permanent black fine-line
 markers
5 enamel paints:
 yellow, dark red, blue,
 light green, and white
Size 1 paintbrush

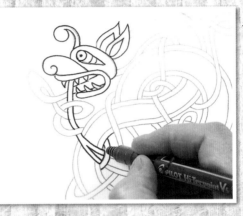

1 Photocopy and enlarge the template of the Celtic animal on page 126, then transfer it to the tracing paper with a black pen before carbonizing the back of the sheet.

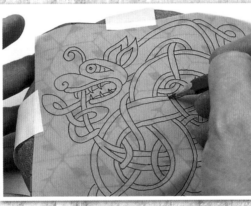

2 Varnish the smooth side of the stone. Put carbon paper under the tracing and stick them both to the stone with masking tape. Trace the design onto the stone.

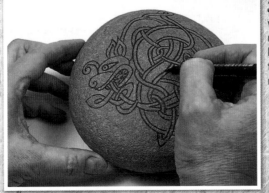

3 Go over the design with a black permanent marker to heighten the lines, allowing you to see the design clearly and so make painting easier.

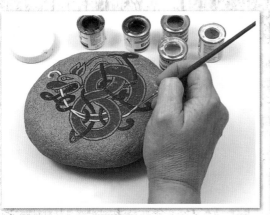

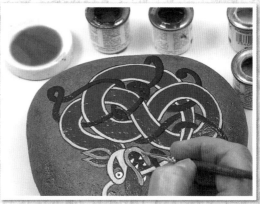

4 Use enamel paint to color the design. Mix it well, as it can thicken at the bottom of the pot. Use a size 1 brush, adding each color in turn, starting with the red, then blue, and then yellow.

5 Continue adding colors, finishing with the green.

6 When the paint has dried go around the design using the black permanent marker to restore the design where the paint has covered your markings.

CHAPTER 4: *BLACK LETTER GOTHIC*

This script is derived from Carolingian minuscule, but from the 12th to 15th centuries it became compressed and angular in the hands of the scribes of northern Europe. An upright hand, it is characterized by closely packed strokes like fence posts.

Dense and black on the page, Black Letter Gothic script heralded a new era in writing, very different from the soft forms previously used. It was sometimes quite hard to read as one letter might even be touching the next.

From the 13th to the 15th centuries, medieval monks right across Europe from the city of Oxford, England, to Paris, France, and Bologna, in Italy, continued to craft books in this hand. The workshops at this time were divided into various groups. Some monks prepared the vellum, while others ruled up the pages.

Skilled scribes wrote the text while the illuminators painted the decorated capital letters. Gold was used in many of these fine books. A mixture known as gesso was made from powdered pumice, lime plaster, and water, and mixed with a fine clay called bole to give it color. This was painted onto the page to make a cushion and the gold leaf applied on top. The technique is known as raised gilding.

At this time many people commissioned such books to be produced specially for them. They would choose the style of book they wanted and told the scribe how long they would be prepared to wait. Those who paid extra got their books first. As a result some craftsmen became rich and famous. The Limbourg brothers, who were illuminators, were highly paid for their art and well-regarded in society.

BLACK GOTHIC MAJUSCULE

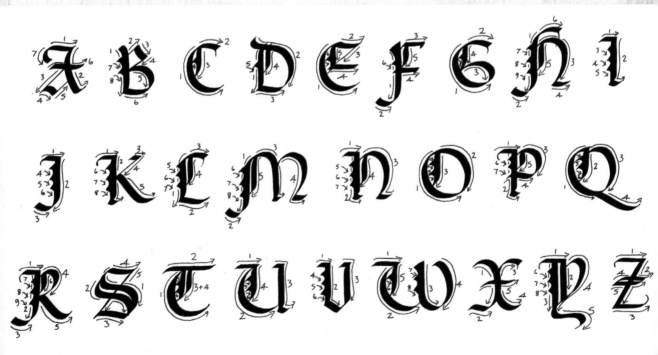

Use the stroke sequence arrows to complete the alphabet.

WRITING THE LETTER "E"

1 Draw a two-line stave, with 7 pen-widths between the top line and baseline. Place the nib on the top line. Curve it around to the left and back to the right as you reach the baseline.

2 Go back to the start point and draw the nib to the right curving the stroke down and back up to the top line.

3 Halfway down the first stroke, draw a horizontal line across the letter.

4 Return to the top pencil line and draw the nib down in a straight stroke to just below the crossbar to form a space between the curved first stoke and this straight stroke.

5 In this space draw a small serif-shaped stroke, placing the nib a little way down the straight line and moving to the left. The last stroke is a thin diagonal line made from the right-hand end of the top line. Draw the nib diagonally down and stop at the horizontal line.

WRITING THE LETTER "M"

1 Curve a stroke to the left and then down below the baseline, curving to the left at the end. Place the nib to the left and curve to the right to meet the first stroke.

2 From the top of the first stroke, draw the nib around to the right in a curve and straight down to the bottom. Draw a foot on the bottom of the stroke.

3 Put the nib three-quarters of the way up the last stroke and draw a more rounded curve to the right. Continue the foot of the last stroke a little further than the last foot.

4 Put the nib on the top pencil line to the right of the first stroke. Draw the nib halfway down the letter and curve to the left at the bottom.

5 The last three strokes are made up of little serif-like strokes. Place the nib slightly left of the first downward stroke, just below where it curves from the top. Draw the shape three times, one below the other.

BLACK GOTHIC MINUSCULE

The bold angular strokes of the Black Gothic minuscule, or lowercase, alphabet are best for design impact, rather than readability. Unlike most other Roman scripts, there are no contrasting thick and thin uprights and—with a few exceptions—the arches are made up of elongated diamond shapes, rather than curves. The techniques needed to produce this script can be difficult to master, but the end result makes all the practice worthwhile.

The Black Letter Gothic minuscule alphabet is written very straight and angular and is somewhat dense in appearance. In this exercise you are going to practice writing the letters "a" and "g." The "a" is made up of three main strokes and the more complex "g" comprises four main strokes.

To start, place a large nib into the holder and then attach your reservoir. Start by ruling up 7 pen-widths to the left of your paper and then draw top and baselines with a soft (2B) pencil. Add an extra line to the stave at 5 pen-widths above the baseline. This gives you the x-height for the minuscule letters.

As you write always check that the nib is at a 45° angle to the paper. If necessary use a triangle or protractor to draw a line at 45° so that you can keep checking.

Start with the pen nib on the x-line. The downstrokes may look straight at first glance but all involve slight curves, which take practice to perfect.

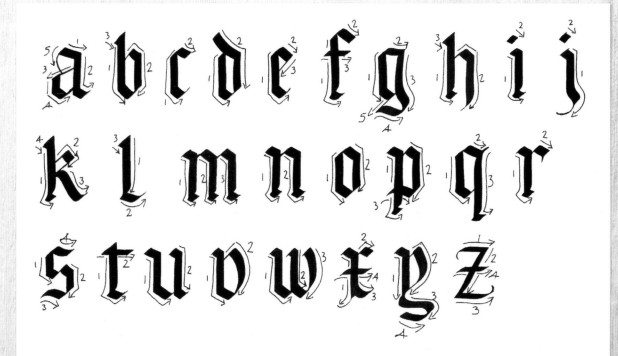

Use the stroke sequence arrows to complete the alphabet.

WRITING THE LETTER "A"

1 Put the nib on the x-line. Draw the first stroke diagonally to the right and then, without lifting the pen, go straight down the paper. Just before the baseline, go to the right diagonal and stop at the baseline. Move up to the right slightly and stop.

2 Put the pen halfway up this stroke. Draw a line diagonally to the left and, without lifting the nib, continue down to just above the baseline again and, without lifting the nib, go to the right to meet the first stroke.

3 Start the last stroke where you started the letter, turning the nib on its right side and drawing a thin, curved line down to meet the middle line, and stop.

WRITING THE LETTER "G"

1 Place the nib at a 45° angle on the x-line. Draw the pen to the left a short way, then straight down until just before the baseline, now diagonally to the right down to the baseline. From here, draw a line diagonally up to the right.

2 From the top draw the nib diagonally to the right in a curved motion.

3 To form the descender, bring the nib downward, moving slightly left, then straight down. Just before the baseline curve a little to the right and then left below the baseline.

4 Return to the end of the first stroke. Put the nib at a 45° angle on the paper and draw the pen down diagonally to the left.

5 From this point to the left, write a curved stroke to meet the end of the third stroke. This completes the letter.

Rotunda

The Rotunda hand is derived directly from Black Letter Gothic. It is also written at a 45° angle, but is slightly more curved and open in its appearance, compared with the straight, angled pen strokes used in Black Letter Gothic.

Use the stroke sequence arrows to complete the alphabet.

NUMERALS

Numerals follow the same basic rules as the letters. Black Letter Gothic numerals include serif-shaped motifs, while the Rotunda script is rounder and more open (hence its name).

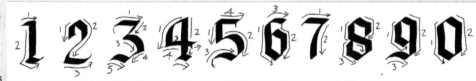

Black Letter Gothic numerals

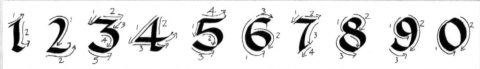

Rotunda numerals

DRAWING AND PAINTING AN ILLUMINATED LETTER

Decide in advance where you are going to apply colors and if you are going to use gold leaf—apply it before painting otherwise the gold will stick to the paint.

To mix gouache colors, put a little paint on a palette and mix with some water, add a drop of gum Arabic and mix until it is the consistency of light cream. For outline work, put a little mixed gouache into a separate palette and mix more water with it to give a thinner consistency. Paint the outline edge of the letter carefully, using a size 00 brush. Keep a nice flow going with the brush.

1 First draw a box shape using a soft 2B pencil and fill the space inside the box with the letter you have chosen.

2 Draw a decorative design of leaves and geometric shapes around the letter.

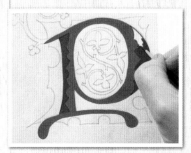

3 Use a size 1 brush to fill in color as smoothly and as quickly as possible to give an even, opaque surface. Allow the paint to dry.

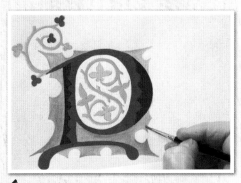

4 Mix a little white gouache with the deep colors and paint over the first color. This adds definition to the design. White can be used to highlight certain areas. Mix this as before, and pick out the design drawn on the thicker parts of the letter.

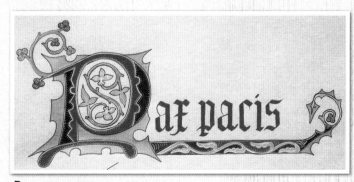

5 Now paint any decoration on the outside of the letter, such as leaves and vines, in green. When the painting is complete and thoroughly dry, go over the outline in deep red with a size 00 brush. Finally, rub out any pencil lines that show on the paper.

Common Mistakes, tips, and problem solving

Common mistakes with the Gothic script include:
- Too much space between lowercase letters. They should be quite close and evenly spaced.
- Bad technique. With lowercase "a," "j," "x," and "y," it is hard to turn the nib onto its right side to make very thin strokes but with practice it can be mastered.
- Too much ink. Avoid blobbing.

- Wrong pen angle. Keep the nib at 45° for drawing clearly differentiated thick and thin lines.
- Rotunda capitals drawn too wide. They must look in keeping with lowercase letters.
- Serif shape drawn too large on the capitals. Try to keep them in proportion with the rest of the letter—especially when using more than one.

Illuminated page

This beautiful project is inspired by the French Duke de Berry's *Book of Hours*–an illuminated calendar. This example uses gold gouache color to dramatic effect. Steps 1 to 4 show the first rough version, for practice. The final work starts with step 5. The finished example (right) is embellished with raised and flat 24-karat gilding to give the flavor of the original.

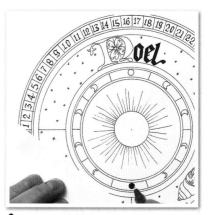

1 Use a compass to draw 11 circles out from the center point at the following diameters:

½ in. (13 mm)	3 in. (7.5 cm)
1½ in. (3.8 cm)	3¼ in.(8.2 cm)
1⅝ in. (4.2 cm)	3⅜ in. (8.6 cm)
2 in. (5 cm)	3⅝ in. (9.3 cm)
2⅛ in. (5.4 cm)	3¾ in. (9.5 cm).
2¼ in. (5.7 cm)	

2 Draw the sun in the center and the segments for the moon phases. To draw the number segments around the outside edge, place a ruler across the circle and put a mark on each side. Allow a little more space for double figures. Now trace the zodiac symbols on page 126.

3 Pencil in the numbers of the days with a size C5 nib. Finally draw the "N" of "Noël" and write the three other letters with a size C2 nib.

Materials

Large cartridge paper
Large turquoise canson paper
Penholder
2 Speedball nibs: sizes C2 and C5
2 ink reservoirs
Black calligraphy ink
5 gouache colors:
 blue, green, gold, red, and white
Gum Arabic
2 paintbrushes: sizes 00 and 1
2 size 4 paintbrushes for mixing
Palette
Jar of water
Fine-line black pen
Large compass
Ruler
Soft 2B pencil
Eraser

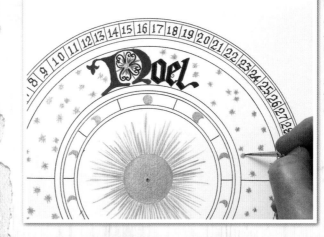

4 Add the gold to the sun and the phases of the moon and stars. Mix the gouache and add this to the capital "N" of "Noël."

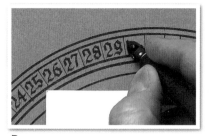

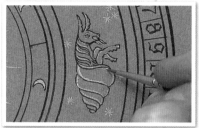

5 On the final sheet of paper draw the circles and mark out the segments for the moon as before. Now paint them in. Also at this stage, draw the "N" of "Noël" and write the three other letters.

6 Put in the gold stars, spacing them evenly. Now draw in the zodiac signs.

7 All that is left is to paint in the letter "N" of "Noël," and the design is finished.

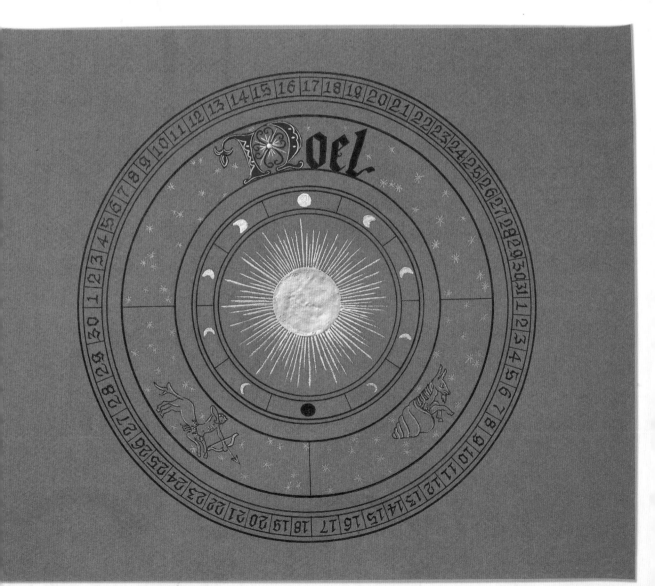

Special gift box

It is lovely to personalize a gift box with the initial of the recipient. Before you start, study the finished letter (right) to get an idea of the strokes to use and then practice using the double-pencil method.

Materials

White card
Practice cartridge paper
Box measuring 6 x 8 in. (15 x 20 cm)
Black calligraphy ink
Penholder and ink reservoir
Speedball size C2 nib
2 soft (2B) pencils
Eraser
Ruler
PVA glue
Scissors
Fine-line black pen

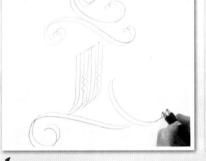

1 Use double pencils to practice the letter freehand a few times. When you are ready to start, draw two lines 5 in. (12.5 cm) long and 5 in. (12.5 cm) apart on cartridge paper to mark the base and top lines.

2 Using the size C2 nib and black ink, write the base of the letter in two strokes about 1 in. (2.5 cm) above the baseline. First, move across to the right and slightly down, then return to the start point and make a spiral to the left.

3 To form the body of the letter draw a narrow diagonal line down to the left 2 in. (5 cm) above the base. This marks the top of four downstrokes. Put the pen on the left side of this line to draw the first downstroke. Make diamond patterns using four short diagonal strokes to the left on the second downstroke, and five short strokes on the fourth downstroke.

4 To the right of the last downstroke, allowing a small gap, draw curved lines to the right. Above the body of the letter, draw a diagonal line to the right. Draw two spirals at either end and add a smaller stroke underneath. Above the last stroke draw the pen down again diagonally to the right. Draw three of these straight lines, adding in the spirals and the other zigzag decoration.

5 Now go below the first four downstrokes that you have made and draw the pen to the right. Add the diamond pattern in the middle, as before, and then curve around into a spiral. Now draw a second line below the last one and add a larger zigzag motif. Add more zigzags to the left of the body, ending in a spiral.

6 Start with a narrow line straight down. This goes along to the right of the body. Now add the zigzag pattern down. Draw another spiral to the right and pull the nib down and to the left. The last part to add here is the tip on the far bottom right. Draw a curved stroke to the right ending with a spiral, and a little one inside going the other way.

7 Use the fine-line black pen to draw triangle shapes inside the letter. Use the same pen to add a fleur-de-lis design at the top left and the leaf shape in the bottom right.

8 Fill in the triangles with the same pen, then take the finished letter and cut around it to fit the lid of your box. Add glue to the card and stick it in place.

Wedding invitation

Black Letter Gothic is ideal for invitations to formal occasions, such as a wedding. The initial letters of bride and bridegroom are symbolically entwined, to signify marriage, and illuminated for dramatic effect. You can practice this several times until you are satisfied and then color photocopy the finished version.

Materials

Tracing Paper
Cartridge paper
White card
Black calligraphy ink
Penholder
2 Speedball nibs:
 sizes C2 and C4
2 ink reservoirs
Ruler
Eraser
2 pencils: soft (2B) and hard (H)
5 gouache colors: orange, blue, magenta, violet, and white
Gum Arabic
Palette
Jar of water
2 paintbrushes for painting:
 sizes 00 and 1
Size 4 paintbrush for mixing
Black fine-line pen
Gold fine-line pen

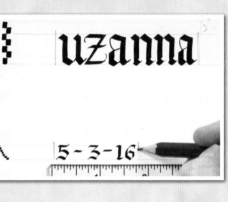

1 Rule guidelines on a sheet of cartridge paper. Mark 7 pen-widths with a size C2 nib and draw base and top lines. Now go up 5 pen-widths for the x-height and rule another line across. Practice writing the names then change to a size C5 nib to practice the date.

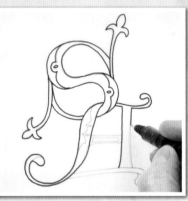

2 Using the example provided, copy the illuminated "S" and "A" letters onto tracing paper in black pen. Follow the general design provided for letters other than "S" and "A."

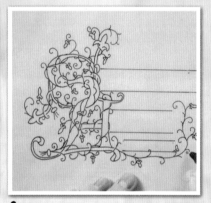

3 Now draw the leaf and vine design over the letters freehand, also on the same tracing paper. Measure the length of the names and mark the dimensions on the same tracing.

4 Use a soft 2B pencil to carbonize the back of the tracing. Turn it over and practice transferring it with a hard H pencil onto a sheet of cartridge paper.

5 Starting from your transferred design on the cartridge paper, practice writing the rest of the two names.

6 Now practice adding color to the invitation. Using a size 4 brush, mix the magenta gouache with a drop of gum Arabic and some water. Paint the outline with the size 00 brush. Use the size 1 brush to fill in color. Wash your brush and change the water when you change color.

7 For the final version of the invitation, take a sheet of card and fold it in half. Follow the same steps as before, transferring the design onto the card. Paint the design as you have practiced and add the green vines. Add gold to the vines and outline the design in black. Rub out any pencil lines that are showing. You can now color copy your wedding invitation as many times as you need using your home printer, if you prefer, or have it done professionally.

CHAPTER 5: *ITALIC*

Italic script is popular for its flourished, free-flowing, yet compressed letters. There are several types, including the formal upright and the cursive hand—both are beautiful to look at and easy to read.

Italic script was established in Renaissance Italy during the 16th and 17th centuries. Scribes of that time had great pen control and could draw ink sketches of figures, animals, intertwining patterns, and very complex capital letters—just with a nib and ink. At this time specialized books were produced to show off the many new and elaborate styles of writing, including the Petie Schole (1587) by Francis Clement and The Pen's Perfection (1672) by Edward Cocker.

The formal Italic hand is characterized by long ascender and descender strokes, which curve above the top line and below the baseline, and the flourished free-flowing and yet rather compressed letters, which are written very straight. The lowercase letters are based on the oval letter "o."

Italic cursive scripts have a slightly different look compared with the formal hand. Some lowercase letters can be joined, as in handwriting, with each letter flowing into the next. They also have elaborate swashes and flourishes. These are made up of loops penned above the top line and below the baseline to enhance the letter, and are regarded as a sign of the real mastery of penmanship.

Italic scripts in general have narrow letters that lean to the right slightly at an angle of 5° and 12° to the vertical. They are written with the pen nib at a constant 45° angle.

To draw the stave, draw a line and then mark down 8 pen-widths and draw another line—this is for the baseline. Measure back up 5 pen-widths and draw a line to give you the x-height. You now have three lines to work from.

ITALIC MAJUSCULE

Use the stroke sequence arrows to complete the alphabet.

WRITING THE LETTER "A"

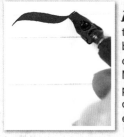

1 Start with the decorative bar at the top of the letter. Maintain the pen angle to define the end points.

2 Add the tail to the bar, starting at the sharp point before pulling the pen around to the right.

3 The left-hand stroke of the letter falls by half its height again below the baseline.

4 Smooth out the end of this stroke with another tail.

5 The right-hand side of the letter is almost vertical by comparison, with a right-angled tail along the line.

6 Finish with a horizontal crossbar, again highlighted by sharply defined ends.

WRITING THE LETTER "P"

1 Write the stroke with a movement to the left so that the tail finishes underneath the start point.

2 Touch the top line of the stave and end the stroke away from the vertical.

3 Join the two together with a short stroke, whose point matches that of the previous stroke.

4 Add a simple flourish to the top of the letter.

WRITING THE LETTER "W"

1 Give a little flick to start, letting the nib touch the top line.

2 Repeat the stroke exactly.

3 Keeping the gap open, write the longer end stroke, pulling the pen down to a point.

4 Add a simple flourish that ends above the top line

5 Copy the angle of the last stroke to join up the two sections of the letter.

ITALIC MINUSCULE

When writing the Italic script, keep the letters even. Do not make the bowl too round or wide. When writing the letters "a," "d," "g," and "q" make the curve on the bottom of the first stroke oval in shape and not too rounded, with the nib going up quite a way at the end of the stroke.

Use the stroke sequence arrows to complete the alphabet.

WRITING THE LETTER "d"

1 Move down from the x-height, but turn sharply at the bottom and come halfway back up.

2 Add a rounded tick to the top, ending it in line with the end of the previous stroke.

3 Bring down the vertical in one stroke, mirroring the turn at the bottom in the tail.

4 Finish with a flourish along the top line.

WRITING THE LETTER "g"

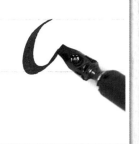
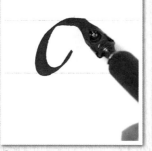

1 The first stroke replicates the first stroke of the "d."

2 Add a horizontal stroke along the x-line, finishing to the right of the previous stroke.

3 Bring the descender below the line in a simple sweep, defining the join at the top of the letter.

4 Add a tail to the descender, starting to the left of the body of the letter.

WRITING THE LETTER "e"

1 Use the full height of the x-line to make a well-defined curve.

2 Enclose the bowl of the letter with the nib at its narrowest at the join.

LINKING LETTERS

When some Italic letters are written next to each other they may be linked instead of being written separately. Alternatively, the lowercase letters can just touch each other. Letter combinations like this are known as ligatures. For example, the "c" and "l" (below) are not joined, but they flow together when they are written close to each other. The capital "T" followed by the letter "h" is another nice combination.

When the crossbar stroke of the "T" is taken across the straight stroke of the "h" they meet and form a loop. Double letters such as "f," "l," and "t" are written slightly closer to each other. With the "f" and "t" the crossbar goes through both letters in one stroke.

When writing the lowercase "s" and "t" (below) next to each other, you can connect them by letting the top arc stroke of the "s" go across to make the crossbar of the "t."

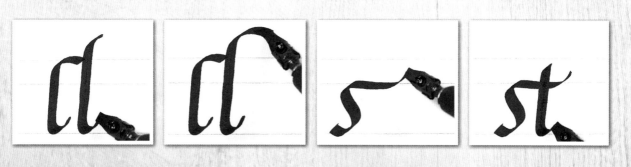

NUMERALS

Numerals should be rounded but with well-defined areas of thick and thin nibwork. Only "0" and "1" stay within the x-height. The numbers "2," "6," and "8" reach the top (capital) line while "3," "4," "5," "7," and "9" drop below the baseline.

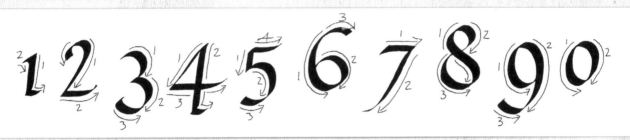

Use the stroke sequence arrows to complete the numerals.

WRITING THE NUMBER "2"

1 Start at the capital height with a sharp turn before descending to the left.

2 Give the horizontal base an upward turn at the end.

3 Define the top of the letter with a tick that reaches the x-height.

WRITING THE NUMBER "8"

1 The main body of the "8" resembles a more vertical, bottom-heavy "S."

2 Enclose the top bowl with a short stroke down to the x-height.

3 From opposite the end of the previous stroke draw a fuller, rounder stroke to enclose the bottom bowl.

WRITING ITALIC LETTERS IN COLOR

Often when writing a piece of black text you would use a larger letter or word in color at the beginning of a line. These letters are also written in the Italic script.

The paint usually used is gouache color. It is mixed with gum Arabic and water to a slightly thinner consistency so that the paint flows easily from the nib and can be written smoothly on the paper, although you can also use calligraphy inks. There are lots of colors available today including metallics—although these do tend to be rather watery.

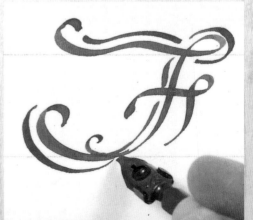

FLOURISHES AND SWASHES

The Italic script uses flourishes and swashes to decorate the letters. Some of the early writing masters were so proficient with the pen that figures and swirling designs were used in the decoration.

The flourishes are made by free-flowing, sweeping movements of the pen nib to create beautiful letters that are almost an art form in themselves. Some decorative strokes are used above the top line in the ascenders and others in the descenders below the baseline. These swashes can fill in empty spaces as much as a few inches below or above the stave. In the middle or at the end of a line, they are joined to the top and bottom strokes of the letter.

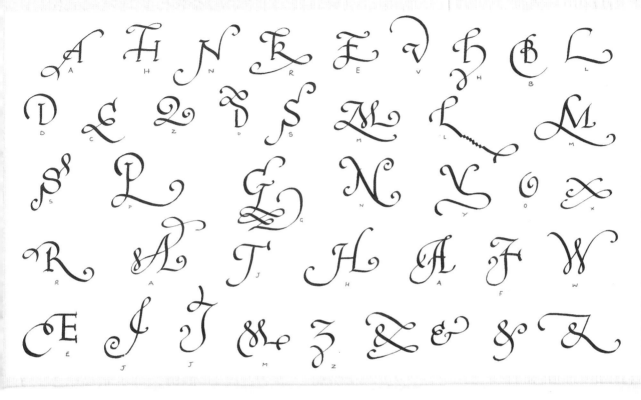

Common Mistakes, tips, and problem solving

- Don't slant the letters too far to the right. Keep them upright when practicing, before leaning them very slightly to the right at a 5–12° angle.
- Some capital letters—for example "A," "E," "W," and "Z"— also change the stroke direction to form the letter. Try writing the difficult letters many times.
- Always try to form the letters based on the condensed, oval-shaped letter "o," never too rounded.

The left-hand letter is too slanted and looks as if it is toppling over. When learning, practice upright letters.

Retain strong distinctions between the thick and thin elements of the letters.

Shakespeare sonnet

The Italic script was well-established by William Shakespeare's time, in the 16th century, so it was the most popular style to adopt when writing love poetry. The elegant flowing strokes set off one of the Bard's sonnets perfectly and, once framed, it makes an elegant addition to any room.

Materials

Black ink
Penholder
2 Speedball nibs: sizes C3 and C6
2 Speedball size C4 or C5 nibs
4 ink reservoirs
Large sheet of cartridge paper
Large sheet of parchment paper
Soft 2B pencil
Long ruler
Eraser
Scarlet red gouache color
Palette
Size 4 paintbrush
Jar of water

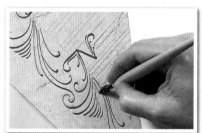

1 Practice on the large sheet of cartridge paper. Pencil in the lines for the poetry, checking where you want to leave extra space for initial capital letters while ensuring lines are evenly spaced and a margin is left on the left-hand side.

2 Start by practicing with a size C4 or C5 nib on the smaller of the lines at the top. Pencil in the letters you will write with the C3 nib—the capital "M" and the letters that make up the first word. This will give you a starting point.

3 Pencil in the lines on the sheet of parchment paper and draw in guides for writing in the capital letters and swashes.

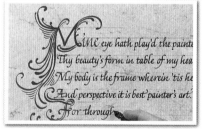

4 On a second sheet of cartridge paper rule lines ¾ in. (20 mm) apart. Apply red gouache to a size C3 nib and glide the nib over the surface, using sweeping strokes. Use the alphabet to help you form the letters (see page 100).

5 Go back to the ruled parchment paper and start to draw the capital letters and swashes over your pencil lines. These are free movements and can be as simple or flourished as you like. Also write the rest of the first word on the stave.

Mine eye hath play'd the painter and hath steel'd,
Thy beauty's form in table of my heart;
My body is the frame wherein 'tis held,
And perspective it is best painter's art.
For through the painter must you see his skill,
To find where your true image pictur'd lies,
Which in my bosom's shop is hanging still,
That hath his windows glazed with thine eyes.
Now see what good turns eyes for eyes have done:
Mine eyes have drawn thy shape, and thine for me
Are windows to my breast, where-through the sun
Delights to peep, to gaze therein on thee;
Yet eyes this cunning want to grace their art,
They draw but what they see, know not the heart.

Sonnet XXIV William Shakespeare

6 Now write in the rest of the sonnet in black Italic script, using the first size C4 or C5 nib. You will notice the first word is written in red following the capital "F" and "N": use the second size C4 or C5 nib for applying the other color. Write all the lettering until you come to the bottom. Use the size C6 nib for the author's name at the bottom of the page. When the ink is dry, rub out the pencil lines.

"Ex-libris" bookplate

The most important works in your library (including this one!) deserve their very own "ex-libris" decorated bookplate or label, bearing your name, pasted into the front. The delicate Italic script and decorative flourishes add an elegance to grace any book. Remember to take equal care when writing your own name.

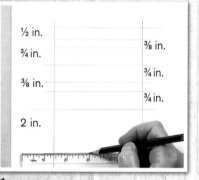

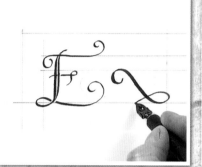

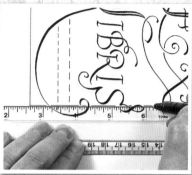

1 Draw a 4 x 6 in. (10 x 15 cm) box on a sheet of cartridge paper. From the top of the box, draw seven lines the following distances apart:

½ in. (13 mm) ⅜ in. (10 mm)
⅜ in. (10 mm) ¾ in. (20 mm)
¾ in. (20 mm) 2 in. (5 cm)
¾ in. (20 mm)

Now measure ½ in. (13 mm) in from the edge of the card on both sides of the box. Draw lines down.

2 First, pencil in the words "Ex Libris," as a guide. Follow this by going over the letters in black ink with a size C5 nib. Start at the top of the double downstrokes of the letter "E." Continue until you have written all the letters.

3 Use the fine-point pen and a ruler to draw in the two dotted lines for your name. Also draw lines in black around the rectangular box.

Materials

Fine-point black pen
Black ink
Violet gouache color
Gum Arabic
Jar of water
Palette
Size 4 paintbrush
Penholder
Speedball size C5 nib
Ink reservoir
Ruler
Soft 2B pencil
Eraser
White cartridge paper
Cream card
Marbled or colored backing paper
PVA glue
Fancy-edged scissors

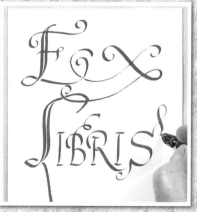

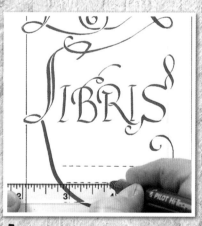

4 Create the writing staves on the card for the final piece. Mix the gouache with a drop of gum Arabic and some water to a smooth consistency. Apply this to your nib with a size 4 brush. Start writing at the same point on the letter "E."

5 Mark lines around the card, ½ in. (13 mm) from the edge, taking care not to touch the violet lines. Now rule two lines for your name.

6 Cut the marbled backing paper 4 in. (10 cm) larger than the card, trimming the edges with fancy-edged scissors if you have them.

7 Using the glue, stick the card down in the center of the backing paper. When it is dry you can fix the plate into the front of a favorite book.

Latin love card

This token of love is written freehand—without guidelines—so you can really accentuate the Italic flourishes. Some of the flourishes end with bright red hearts as a sign of your true devotion. To give the card an authentically "antique" look, the card edges are roughly torn to simulate aging.

Materials

3 sheets of cream card
Penholder
Speedball size C6 nib
Ink reservoir
Soft 2B pencil
Ruler
Eraser
Size 4 paintbrush
Crimson red gouache color
Gum Arabic
Jar of water
Palette

1 Take a piece of cream card and practice writing letters and flourishes freehand without guidelines. Mix up gouache with a little gum Arabic and some water, then fill the size C6 nib using the size 4 brush. As you write keep the letters flowing and include a flourished heart.

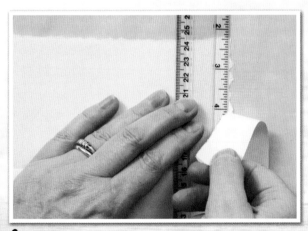

2 Take a sheet of card and fold it in half. Cut off any excess to make a card roughly 3 x 7 in. (7.5 x 18 cm). Open out the card and "age" it by roughly tearing each edge along a ruler.

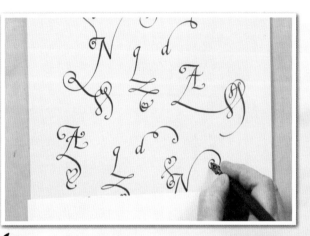

3 On a practice sheet, measure 1½ in. (3.8 cm), 2 in. (5 cm), and 2½ in. (6.3 cm) down from the top fold and draw the three guidelines.

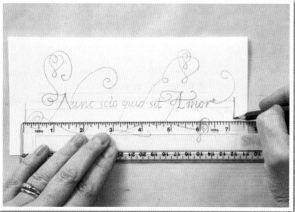

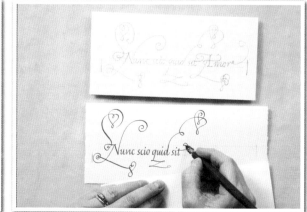

4 Use the soft 2B pencil to roughly pencil in the phrase you are going to write. Measure the length of the writing and transfer the marks to the start and end of the lines on the card.

5 Load the brush with crimson gouache and apply to the pen nib. Write the card, keeping the letters and flourishes flowing. When dry, rub out the pencil lines.

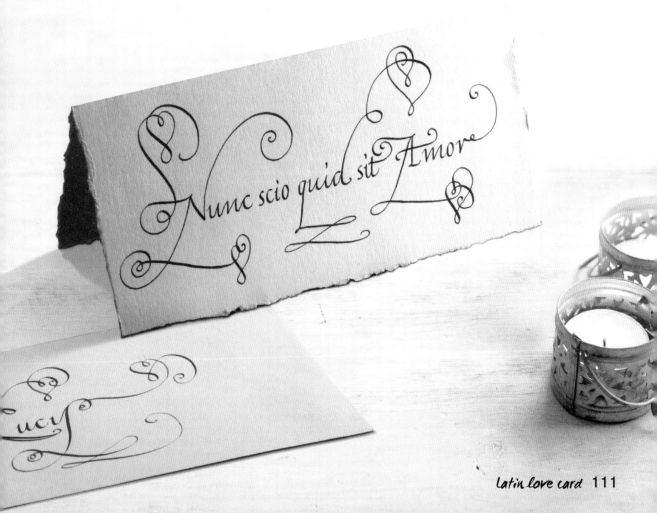

A celebration menu in French

Italic script is used in French restaurants and adds a touch of sophistication to the menu. Next time you host a celebration meal or a dinner party for friends, why not send your guests an elegant menu in advance so they know what they'll be eating? They can keep it as a reminder of the evening, too.

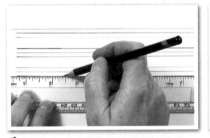

1 Draw a top line 1¼ in. (3.2 cm) from the top of the paper. Now measure in ⅜ in. (10 mm) for the left margin. Measure down ⁵⁄₁₆ in. (8 mm) and draw a base- line, then measure up ³⁄₁₆ in. (5 mm) and draw the x-line. Repeat until you have nine staves, leaving a space of ⅜ in. (10 mm) between lines.

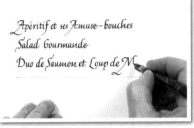

2 Practice writing the menu with a size C5 nib, starting from the top stave.

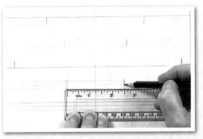

3 Measure the length of each line of writing. Put pencil marks at the beginning and end of each line, and note down the measurement.

4 Find the center of the sheet of parchment paper, and draw a line down. Create the lines as before, but this time ignore the margin and leave a ⅝ in. (16 mm) gap between each line of the menu. Center each line of the practice writing, marking the beginning and end of each line you will write.

5 Copy out the menu from your practice sheet, taking care to use the same amount of space for each line to keep the menu centered.

Materials

Penholder
Speedball size C5 nib
Ink reservoir
Black ink
Soft 2B pencil
Eraser
Ruler
White cartridge paper
Green vegetable parchment paper

6 Add a flourish motif at the bottom of the menu to complete it. Rub out the pencil lines when the ink is completely dry.

Apéritif et ses Amuse-bouches

Salade Gourmande

Duo de Saumon et Loup de Mer aux Deux Sauces

Sorbet Normand

Noix de Veau aux Pleurotes et ses Petits Légumes

Salade de Saison

Assiette de Fromages

Nougat Glacé

Café

CHAPTER 6: *COPPERPLATE*

Copperplate writing became popular in the 17th century, but is more commonly associated with the 19th century. A fine flamboyant style, it can been seen on documents from the era.

The name "Copperplate" derives from the sheets of metal that engravers often used in the manufacture of printed matter. They were sometimes etched with very fine thin and thick lines to resemble the writing of that time.

When Copperplate first appeared, most lettering was done with goose quill pens, but by the middle of the 18th century growing literacy rates increased demand for steel pens, and steel nibs were manufactured specifically for Copperplate writing. Soon there were many different types of pointed nibs. Many countries, including the United States, Britain, France, and Holland, all claim to have invented the first steel pen.

A fine-pointed tip is known as a Copperplate nib. It is narrow with a split down the middle and so was quite different than the cut goose or swan quill pens of before.

Copperplate writing was an important subject at school. Known as "handwriting," it was taught to British school-children of the Victorian era (19th century). A child would practice with white chalk on small slate boards by copying from the examples written on the blackboard. The children then progressed to using a wooden penholder and a steel-pointed nib to copy letters from a copybook.

Unlike other forms of Roman script, the different line thicknesses are mainly achieved through pressure, not just nib angle. Thick lines are made by putting more pressure on the nib, allowing more ink to flow. Thin lines are produced by easing up on the pressure of the nib and letting it glide.

The upstrokes are thin, while downstrokes are thick. The writing is characterized by its right-slanted angle with large loops and swashes going above and below the guideline.

COPPERPLATE MAJUSCULE

Use the stroke sequence arrows to complete the alphabet.

STEP-BY-STEP DIRECT-PEN TECHNIQUES

The Copperplate alphabet is made up of distinct thick and thin lines. It is a free-flowing form of writing and so it is important to keep the pen moving at all times.

All the lowercase letters start on the baseline, not at the top line, as with other Roman scripts, and the nib slides up the paper. Loops are characteristic of this style and should be made as even as possible. Try to get a feel for the writing and let the pen glide over the paper.

The capital letters start in different places. Some have either loops or simple spiral strokes. As you write try to make the letters nice and round, ensuring they have an even slant to the right. Look at the step-by-step stroke direction to help you form this beautiful alphabet.

As the alphabet is written with a fine-point pen nib, you do not mark nib-widths on the left side of your paper, so you do not need to mark writing staves, unlike the other Roman scripts. The usual method is to mark just one baseline. If you prefer to rule lines across the page to help you with the writing height, then using a measurement of ⅜ in. (10 mm) for capital letters and ¼ in. (6 mm) for lowercase letters works well when starting to write Copperplate.

Start by using a soft 2B pencil to mark a line across the paper for the baseline. Measure ⅜ in. (10 mm) up and draw a second line as a guide for capital letters and lowercase letter ascenders. Keep the pen at a constant angle of 45° to the paper.

WRITING THE LETTER "A"

1 Start with a swirl begining at the x-height, and then write a curved stroke in one movement. The angle may seem flat but practice until you discover the best shape.

2 Now write the right-hand downstroke, which is much steeper than the previous stroke.

3 The movement continues into the crossbar, which becomes a tear-shaped stroke that almost reaches the height of the letter before cutting back through the first stroke.

WRITING THE LETTER "R"

1 The first stroke of the "R" seems to reflect the first stroke of the "A" but is, in fact, more upright. It also drops below the baseline between the swirl and ascender.

2 The rest of the letter is written in one movement. Halfway through, a clean curve has risen above the previous stroke before crossing it above the top line of the stave.

3 Continue the curve to make the bowl of the "R" before making a looped change of direction to create the letter's prop, which sits on the baseline.

COPPERPLATE MINUSCULE

Like the Italic, hand Copperplate lettering involves fancy flourishes and swashes. But unlike the pronounced slant and exaggerated loops and flourishes at the beginning and end of capitals, the looped lowercase letters are fairly simple and upright and formed from open spirals and curves. The letters below are shown apart for clarity, but when writing join each one to the next in a word without lifting the nib from the paper.

Use the stroke sequence arrows to complete the alphabet.

WRITING THE LETTER "F"

1 In contrast to the capitals, the lowercase letters are upright, so ensure that after the loop your first stroke is almost vertical.

2 From the baseline, continue down before curving sharply up to finish at the first crossing.

3 Complete the letter with a small, delicate twist that crosses the letter at the same position.

WRITING THE LETTER "Z"

1 Starting at the baseline, curve up to the x-line before turning along it. Then come sharply down, mirroring the angle of the curve in a straight line to halfway between the lines.

2 Move the pen in a smooth clockwise turn, returning to the baseline and finishing just below it.

USE OF COLORED INKS

This script works well using waterproof colored ink and the Copperplate nib.

However, pointed nibs can get blocked easily so, to avoid this problem, when mixing gouache try to make the color a more watery consistency.

Apply the gouache with a brush in the usual way but keep washing the nib with water regularly as you write.

Common mistakes, tips, and problem solving

Making the strokes too wide: Copperplate letters are relatively narrow, so try to make even strokes at a flowing pace, and do not use too much pressure.

Pressing too hard when making your downstrokes: This can cause the ink to bleed into the paper.

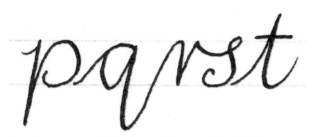

Leaving spaces: All the letters in a word should join up and the nib only rarely lifts off the paper. Let the pen glide across the surface and get a feel for holding the pen and forming the letters. Practice putting pressure on the nib and taking it off again. Upstrokes are light and thin, downstrokes are thicker.

Being too adventurous with flourishes at first: Start by doing practice flourishes to get the feel for the Copperplate alphabet before applying them to the letters.

Copperplate minuscule 117

Birth announcement

For special announcements, such as the birth of a baby, Copperplate writing adds an air of formality and authority that cannot be bettered. Practice writing the infant's name several times and, as an extra touch, be sure to add a flamboyant flourish drawn from the tail of one of the letters—it does not need to be the last one.

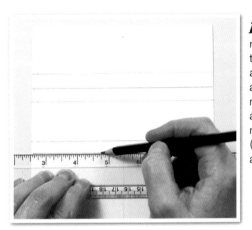

1 Take a sheet of practice cartridge paper and cut it in half. Use the ruler to find the center line and draw a pencil line down the paper. For the guidelines, measure 1⅜ in. (3.5 cm) down from the top of the paper and draw a line across. Measure down from this line 1⅛ in. (5.4 cm) and draw another line across for the baby's name. For the birth weight measure down 1⅛ in. (3 cm) from the second line and draw a line across. Measure down another ⅜ in. (10 mm) for the baseline. Finally measure up from the baseline ⁵⁄₁₆ in. (8 mm) and draw a line 1 in. (2.5 cm) long to the left of the center line. Measure up ¼ in. (6 mm) and draw a line 1⅜ in. (3.5 cm) long to the right of the center line.

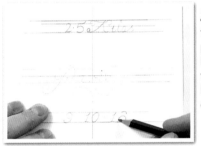

2 Pencil in the wording, practicing the baby's name, weight, place of birth, and date of birth.

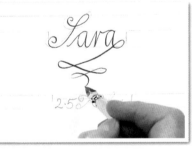

3 Fill your nib by dipping it into the red ink, and start writing. Cover the pencil wording with red ink, continuing through the flourish.

Materials

8½ x 11 in. (21 x 28 cm) cartridge paper
Pale pink parchment paper
Penholder
Copperplate nib
Black calligraphy ink
Red waterproof ink
Soft 2B pencil
Ruler
Eraser

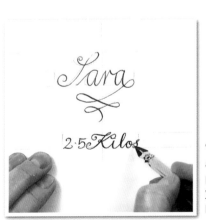

4 Move down to the next set of lines and do exactly the same, covering the pencil with black ink. Continue until you have written all the lines on the practice sheet.

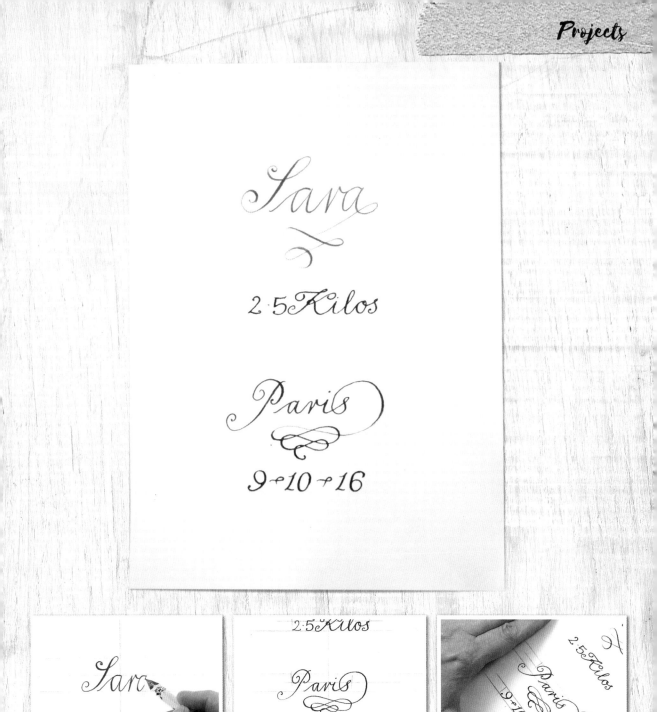

Sara

2·5 *Kilos*

Paris

9·10·16

5 Take the parchment paper and mark guidelines on it exactly as before. Start writing the baby's name on the top stave in red ink.

6 Copy out the other lines in black ink, filling in the weight, place of birth, and date.

7 Rub out the pencil lines when the ink is completely dry.

Place name cards

Beautiful handwritten place cards add elegance and originality to a dinner setting. Once you master this skill you will find you are in constant demand from friends to do the same for them! Another advantage—practicing all those names will help you to polish up your own handwriting.

Materials

Practice cartridge paper
Blank place cards
Violet waterproof ink
Pen holder
Copperplate nib
Soft 2B pencil
Ruler
Eraser

1 Take a piece of cartridge paper and rule three guidelines across it. Measure ⅜ in. (10 mm) between base and top lines and add a line ¼ in. (6 mm) up for the x-height. Practice writing on cartridge paper and then measure the length of each name and note it down.

2 Rule three guidelines on a blank place card, drawing the lines using the same measurements as before. Find the center of the card and transfer the length measurement ensuring it is centered. Put a pencil mark where the name starts and finishes.

3 Place the nib on the card either at the base or top line, depending on which letter the name starts with, and write the name.

4 Take care to give the capital letters a flourish, as with the "L" here.

5 When the ink has dried completely, rub out the pencil lines with an eraser.

TEMPLATES

The templates in this section are printed at their actual size, and do not need to be enlarged. Refer to the relevant project pages for how to use each template.

Petrarch border (page 64)

Uncial zoomorphic motif (page 77)

Uncial zoomorphic motif (page 77)

Uncial zoomorphic motif (page 77)

Uncial zoomorphic motif *(page 77)*

Uncial zoomorphic motif *(page 77)*

Uncial design *(page 77)*

Uncial design *(page 77)*

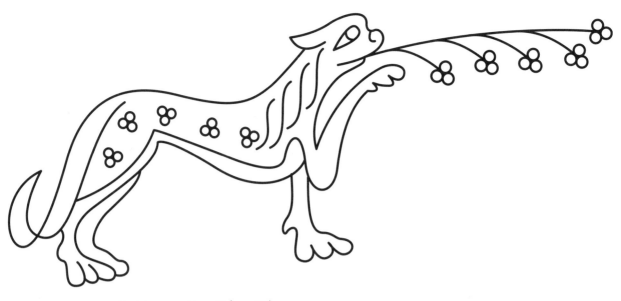

Uncial zoomorphic motif (page 77)

Uncial design (page 77)

Uncial design (page 77)

Uncial design (page 77)

Uncial design (page 77)

Illuminated Letter—Uncial Capital (page 80)

Uncial design (page 77)

Illuminated letter (page 76)

Animal on stone (page 86)

Illuminated page motif (page 94)

Wooden box design motif (page 84)

Illuminated page motif (page 94)

CALLIGRAPHY SUPPLIERS

Blick Art Supplies
www.dickblick.com
General art and craft
supplies

The Calligraphy Company
www.calligraphy.co.uk
A wide range of calligraphy
supplies.

L. Cornelissens & Son
www.cornelissen.com
A huge selection of
calligraphy materials,
brushes, and pigment
powder.

Curry's Artists' Materials
www.currys.com
General art and craft
supplies

DeSerres Art Supplies
www.loomisartstore.com
Online and stores across
Canada.

Exaclair Limited
exaclairlimited.com
Brause nibs and holders,
Schut mill papers, and
calligraphy pads.

Falkiner Fine Papers
store.bookbinding.co.uk
A wide range of specialist
paper, calligraphy, and
bookbinding supplies.

J. Herbin
www.jherbin.com
Purveyor of handmade
French and Italian inks,
quills, and reed and
glass pens.

The Japanese Paper Place
www.japanesepaperplace.com
Japanese and other
imported and handmade
papers.

**Jerry's New York Central
Art Supply**
www.jerrysretailstores.com/
new-york-ny
Extensive selection
of papers.

John Neal Bookseller
www.johnnealbooks.com
Books and supplies,
including nibs for left-
handers.

**Opus Framing & Art
Supplies**
opusartsupplies.com
Locations in Canada.

Oriental Art Supply
www.orientalartsupply.com
Japanese and Chinese ink
sticks and brushes.

Paper & Ink Arts
www.paperinkarts.com
Vast selection of books and
supplies.

Scribblers Calligraphy
www.scribblers.co.uk
Calligraphy supplies.

Sepp Leaf Products
www.seppleaf.com
Traditional gold and metal
leaf and gilding supplies.

INDEX

NIB SIZE CHART

While William Mitchell roundhand nibs are pictured throughout this book, all instructions refer to Speedball nibs, which are the most widely available brand in North America. The table below provides specific nib widths in millimeters and corresponding sizes for Speedball, William Mitchell, and Brause brand nibs. If you are using a different make altogether, use the millimeter measurement to find the relevant alternative.

WIDTH (MM)	SPEEDBALL STYLE C (FLAT PEN POINTS)	WILLIAM MITCHELL ROUNDHEAD (MM)	BRAUSE
4	C1	0	4
3	C2	1	3
2.5	-	1.5	2.5
2	C3	2	2
1.5	C4	2.5	1.5
1.25	-	3	-
1	C5	3.5	1
0.75	-	4	0.5
0.6	-	5	-
0.5	C6	6	-

GLOSSARY

ascender The uppermost part of a letter such as "l." It runs above the x-line.

baseline The line on which the main body of the letter rests.

bottom line The bottommost guideline in a stave. Also called the descender line, it marks the line for lowercase letter descenders.

bowl The rounded part of letter such as "o."

Capital line see top line.

crossbar The horizontal line in a letter such as "t."

descender Bottommost part of a letter such as "j." The descender runs below the baseline.

guideline Generic term used here to describe the various pencil lines that guide calligraphy writing.

majuscule Uppercase, or capital, letter.

minuscule Lowercase letter.

serif Short decorative stroke at the end of a letter.

stave A series of guidelines, usually two to four, used to direct calligraphy writing.

top line The topmost line in a stave. Also called the capital line or descender line, it marks the line for the tops of uppercase letter and lowercase letter ascenders.

x-height The space between the baseline and the x-line. It is the height of a standard lowercase letter, such as "x."

x-line The guideline between the baseline and the top line. It marks the line for the tops of standard lowercase letters, such as "x."